IMAGES
of America

DELAWARE RIVER
SCENIC BYWAY

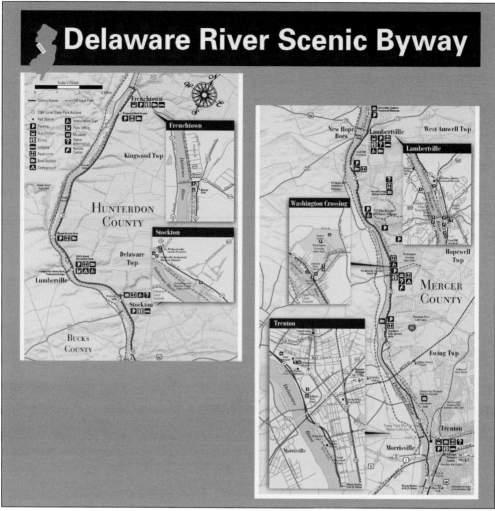

Delaware River Scenic Byway

The authors share a passion and appreciation for the area traversed by the Delaware River Scenic Byway. This map shows both historic and present-day treasures the Byway has to offer. We hope this pictorial story will enable both visitors and lifelong residents to understand the planning required to accommodate the capital city of a growing state, embrace the intersection and connection of Interstate 95, and protect the Byway's scenic value and natural resources, while providing safe, weather-resilient roads from which to experience our nation's story of independence and development. (Courtesy of the Delaware River Scenic Byway Corridor Management Committee.)

ON THE COVER: Delaware River canal boats, pulled by teams of mules, carried commodities from the coal and ore producing areas of the Lehigh Valley to the manufacturing cities of Philadelphia and New York via the Delaware and Raritan Canal and its feeder canal from Trenton to Raven Rock, New Jersey. In this enlargement, the team is out of view to the right. (Courtesy of the Delaware River Canal Commission.)

IMAGES
of America

DELAWARE RIVER
SCENIC BYWAY

Marion M. Kyde, PhD; Edith S. Sharp;
Stephanie Fox; and Keith Strunk

ARCADIA
PUBLISHING

Published by Arcadia Publishing
Charleston, South Carolina

Printed in the United States of America

Library of Congress Control Number: 2013946741

For all general information, please contact Arcadia Publishing:
Telephone 843-853-2070
Fax 843-853-0044
E-mail sales@arcadiapublishing.com
For customer service and orders:
Toll-Free 1-888-313-2665

Visit us on the Internet at www.arcadiapublishing.com

This book is dedicated to Cindy Bloom-Cronin for her enthusiastic guidance during the development of the Delaware River Scenic Byway and six other New Jersey byways, and in recognition of her passion for the National Scenic Byway Program.

CONTENTS

ACKNOWLEDGMENTS

The authors would like to acknowledge the individuals and organizations devoted to gaining recognition for an important road along a section of the Delaware River, a National Wild and Scenic River, as New Jersey's first State Scenic Byway as well as a National Scenic Byway.

We are grateful for the enthusiasm of many individuals and organizations whose help in gathering images made this book possible.

For all of their assistance, the authors want to recognize and thank the following: Carl Cathers, a local historian who has served as an indispensable link to the Delaware River region's past; Jeff McVey for his insight and knowledge; John Kellogg for his enthusiasm and understanding of the importance of historic artifacts, which led him to save the pictures long before this book was ever conceived; Peter Osborne for his willingness to share his resources; Karl Neiderer for sharing family history; Dave Miller for his contribution of historic photographs of Frenchtown; and Richard Burton, whose wonderful collection of vintage images of the area can be found on Flickr.com (user rich701).

This book would not have been possible if not for the following government agencies: the New Jersey Department of Transportation, for its foresight in documenting the progress of a beautiful road's development and for granting access to the archival pictures; the National Park Service, for its continued commitment to protect and assess our national treasures so they can be shared with the public at large; the Delaware and Raritan Canal Commission, for access to its archival photographs and for its vigilant protection of the Delaware River Scenic Byway (DRSB) viewshed; the New Jersey Department of Environmental Protection Division of Parks and Forestry; New Jersey State Library; and the Federal Highway Administration.

Lastly, the authors want to acknowledge the importance of the DRSB Corridor Management Committee, including the Delaware River Greenway Partnership, Delaware River Mill Society, Hunterdon Land Trust, the Mercer County Planning Division, The New Jersey Water Supply Authority, Delaware and Raritan Canal State Park, the New Jersey Conservation Foundation, D&R Canal Commission, New Jersey Department of Environmental Protection's Green Acres Program, New Jersey Department of Transportation, and the National Park Service.

Images credited to (NJDOT) are courtesy of the New Jersey Department of Transportation Archival Library.

INTRODUCTION

Four colorful parallel threads—the free-flowing Delaware River, the right-of-way of the iron and steel railway, the hand-dug feeder canal, and the road—form the warp on which history wove the ribbon that is the Delaware River Scenic Byway.

Before a single European boot made footfall in the rich alluvium of the Delaware River Valley, Lenape moccasins trod out trails from fishing village to hunting camp to permanent settlement along the great Lenapewihittuke (River of the Lenape). One such trail became over time a dusty coaching route, a state arterial, the John Fitch Parkway and the Daniel Bray Highway, the first New Jersey Scenic Byway, and finally, a national byway from Trenton to Frenchtown.

At the time of European contact, the Sanhickans had established a permanent base camp on both sides of the river near the mouth of Assumpink Creek, current-day Trenton and Morrisville, Pennsylvania. Artifacts from archeological excavation along Route 29 are displayed in the New Jersey State Museum in Trenton, and descendants of these people are recognized as a tribe by the State of New Jersey.

Late in the 17th century, English Quakers settled the middle Delaware Valley. They purchased land for farms and settlements from the indigenous Lenape, and erected strategically located mills and ferries, using the power of the river to process grains into food and feed, logs into lumber, and seeds into oil.

The early Quaker settlers of West Jersey needed not only land to farm, but access to a river landing for contact and trade, as the roads of the time were rudimentary. The shallow section of the Delaware just above the Trenton Falls was ideal. Stacy's Mill, built in 1679 near the mouth of the Assumpink, anchored the village of Trenton. Scotsman William Trent rebuilt the mill in 1714 and erected a mansion for his family, now the William Trent House. "Trent's town" was laid out with its four main streets according to his plans.

Lambertville began as Coryell's Ferry in 1732; it supported both a gristmill at the head of the Falls, and a saw mill on Swan Creek. Coryell's Ferry has enormous historic significance as the crossing point for the patriot army in 1776.

Arguably the most important mill complex arose on John Prall's property, just upstream of current-day Stockton at Reading's, later Howard's, Ferry. The Prallsville complex boasted a grist mill, saw mill, oil mill, general store, and several stone dwellings. Today, the entire site is owned by the Delaware and Raritan Canal State Park, and listed in the National Register of Historic Places.

The northernmost important river settlement is centered on Lawry's Grist Mill, and a saw mill, dating from 1758, on the Nishikawick Creek at Calvin's Ferry, present day Frenchtown.

Three modes of river transportation moved natural resources and commodities along the corridor during the 1700s: log rafts, coal arks, and Durham boats. The locally designed and built Durham boats carried Gen. George Washington and his soldiers across the river to their historic

rendezvous with unsuspecting hired Hessian troops, which turned the tide of the Revolutionary War in favor of the patriots in the Battle of Trenton.

All three transport types were risky in the rapids and shallows of the Delaware. In 1830, New Jersey chartered the Delaware and Raritan Canal, to be built as the final link in an inland waterway from Massachusetts to Georgia, and as a safer way to transport goods. It, with its 22-mile feeder canal from Bull's Island to Trenton, superseded the river as the primary transportation route for New York and Philadelphia. For almost 100 years, it supported mule-drawn boats carrying coal, foodstuffs, and people along the middle Delaware, though its heyday lasted only a few of those years.

In turn, the canal was rendered redundant by the Belvidere Delaware Railroad, built primarily to facilitate the transfer of pig iron from the smelters of Phillipsburg to the processing plants in Trenton: the General Ironworks and the Roebling Wire Mills. By 1900 the canal was nearly out of business, and it was closed down in 1932. The railroad enabled the further development of the towns and villages in the corridor: Frenchtown, Stockton, and Lambertville.

Railroad tracks were shortly surpassed in importance by roads. Even as the canal began to fade in importance, and rail transport dominated the corridor, road building was taking place along the river and canal, connecting small villages and working mills to the bustling Trenton metropolis. In its earliest days, the Byway was no more than a series of narrow dirt roads between river settlements traveled by horse-drawn vehicles and on foot. Only after 1915, when the commissioner of public roads called the river road "one of the most beautiful drives in New Jersey," did it achieve prominence as a major arterial.

A state named highway, the Delaware River Drive, was proposed in 1911 to run from Trenton to New York. A 1913 map shows it in part as Route 175. In 1927, this was renumbered as part of State Route 29, planned to run diagonally from Trenton to Newark; the river road from Lambertville to Frenchtown was labeled 29A. New Jersey renumbered its highway system in 1953, and Route 29 was redefined to continue from Lambertville to Frenchtown on the old river road.

Plans for a limited access highway along this route date from 1932 and include a proposal for a parkway along the entire scenic Byway corridor. These plans never materialized. A portion, however, was built between 1954 and 1957 from Warren Street to Interstate 95 and the Scudder Falls Bridge; it was called the John Fitch Parkway.

After crossing the Delaware and Raritan Canal, Route 29 narrows to two-lane River Road, paralleling the river and the feeder canal. Traversing Hopewell Township through the unincorporated villages of Titusville and Washington Crossing, it becomes a four-lane highway at Lambertville for a short distance. Beyond the intersection with US Route 202, it crosses into Kingwood Township and becomes once again a two-lane highway, ending at bridge Street in Frenchtown.

Such is the physical corridor of the Scenic Byway. Along this route, much of the early history of the United States is preserved, interpreted, and open to visitors.

Several days will be needed to explore the historic resources of the Byway. The city of Trenton, with its rich pre-Revolutionary and Revolutionary history, and as one-time capital of the country, provides a fitting introduction. The oldest building in the city, the William Trent House, headquarters for the Hessian mercenaries and later for Washington's officers, is a National Historic Landmark.

South River Walk Park celebrates Trenton's history and its connection to the Delaware River from earliest settlement to modern times. The Old Barracks Museum, built in 1758 while New Jersey was still a colony, housed troops during the French and Indian War. Just north of the State House Historic District, Ellarslie Mansion, home of the Trenton City Museum, sits in the 100-acre Cadwallader Park, the last park ever designed by Frederick Olmsted.

Washington Crossing State Park spans the river, as Washington's troops did on that long-ago Christmas night. Both the New Jersey and Pennsylvania segments provide interpretation of this important event and its meaning for the Colonies. On the Titusville (New Jersey) side, a visitor center, historic ferry house, walking trails, and a nature center provide recreational opportunities.

Traveling north on the Byway, visitors can learn about farm life and farming practices around the turn of the 19th century at the Howell Living History Farm. On the other side of Lambertville,

the Holcombe-Jimison Farmstead Museum preserves the Delaware Valley's farming heritage from the 18th to the 20th century. These large preserved farms provide opportunities to interact with trained docents as well as domestic farm animals.

Little Stockton Boro, site of the oldest public schoolhouse still in use (1872), contains the sprawling 18th and 19th century Prallsville Mill Industrial Complex. The several mills made clever use of the power of the river to process lumber, grains, and oilseed crops. The restored mills and the Prall House across the Byway host a visitors' center and a small museum.

Connections to Pennsylvania are important to the history of the Byway. From 1690 to 1806, transport across the river was by ferry or small watercraft. Today 11 passenger, pedestrian, and rail bridges connect New Jersey and Pennsylvania's River Roads and the river towns along them.

The first bridge to span the river, opened to traffic in 1806, was a wooden covered structure at the site of the current "Trenton Makes" bridge. Its stone masonry still supports the replacement bridge, erected in 1928. Two additional bridges plus a railroad trestle connect New Jersey to Pennsylvania at Trenton.

Calhoun Street Bridge, the oldest roadway structure between the two states, was 130 years old in 2013. As the longest (and the only wrought iron) bridge in the Delaware River system, it is listed in the National Register of Historic Places and on the historic registers of both states.

The bridges carrying US 1 and I-95 were built in the late 1950s. The Scudder Falls structure on I-95 replaces the Yardley-Wilburtha Bridge destroyed in the flood of 1955. At Washington Crossing, bridges from 1831 and 1842 were also destroyed by floods, the last in the disastrous flood of 1903. The existing structure was erected in 1904 on the original piers.

Connecting New Hope to Lambertville is a bridge built in 1904 as a private toll bridge. It was the third at this location, replacing wooden bridges carried away in the floods of 1841 and 1903. It is the only steel truss bridge in the system, and supports the most pedestrian traffic. On a single weekend day, 14,000 people have walked across this span. The cantilevered walkway on the downstream side affords a nearly unrestricted view as far as the next bend in the river.

A second New Hope–Lambertville Bridge bypasses the two towns entirely, carrying Route 202 over the river on a modern toll bridge.

The Centre Bridge–Stockton wooden span at Reading's Ferry (1914), the only bridge not seriously damaged in the 1903 flood, was demolished in a nighttime fire in July 1923. A real-time plein air painting by New Hope impressionist Edward Redfield documents the efforts of local fire brigades to save it. A six-span riveted steel truss bridge replaced it in 1927.

A Roebling designed and built bridge, the Raven Rock–Lumberville pedestrian bridge lies within the Bull's Island Recreational Area. The original bridge, built in 1850 as a wooden vehicular structure, fell victim to the 1903 flood and was replaced by a steel structure. In 1944, the steel bridge was closed to vehicles and rebuilt as a pedestrian walkway on the original 1856 masonry in 1947.

The most northerly bridge along the Byway, Uhlerstown-Frenchtown Bridge was spared the flood of 1841, since the first wooden structure was only built in 1844. It did not fare so well in 1903, and two spans were washed downstream and rebuilt of steel. A modern riveted steel Warren truss structure replaced this steel-and-wood chimera in 1931.

Though no longer economically viable after the early 1900s, the D&R Canal became an important water supply source for the New Jersey river communities. To protect it from development and disintegration, New Jersey purchased the waterway in 1932. In 1973, the canal and many adjacent structures were listed in the National Register of Historic Places, and it became a state park the following year. Half of this park lies along the Byway and the feeder canal, which begins at Bull's Island six miles north of Lambertville and flows directly through the town south to Trenton. An elaborate locking system built in 1852 transferred coal barges, traveling the Delaware Canal from the Lehigh Valley in Pennsylvania, into the river and thence to the Lambertville Lock, the feeder canal, and eventually to the industries in New Brunswick and New York. A section of the Belvidere Delaware Railroad corridor from Bull's Island to Frenchtown was purchased and added in the 1980s. The park's trail system was designated a National Recreation Trail in 1992.

One important state Natural Area, defined as having retained natural character or having rare or endangered species, is located within the park. Bull's Island Natural Area is a fine example of a lowland floodplain forest and is a designated Important Birding Area.

The third most visited attraction in the state, the canal with its historic structures provides multifaceted recreational opportunities, access to Byway sites, and an intact example of the growth and industrialization of our country during its early history.

The Prallsville Mill Complex, centrally located along the Byway in the Delaware and Raritan Canal State Park, is managed by the Delaware River Mill Society, a private nonprofit organization. It offers cultural attractions such as art exhibits, quilt shows, and theater and musical events, as well as information about the Byway and its resources. The Mill Society has the responsibility to restore, preserve, operate, maintain, and interpret the site. Housed in the complex are the offices of the New Jersey Conservation Foundation, Delaware River Greenway Partnership, Artsbridge, River Union Stage, Delaware River Scenic Byway, Sage Girl, and the Opera Project, as well as that of the Mill Society.

The New Jersey Department of Transportation oversees the Scenic Byway program. A steering committee composed of representatives from nonprofits, communities, interested citizens, and government agencies is responsible for Byway projects and promotion. Projects include a pedestrian overpass, a reconstructed canal swing bridge, upgraded public rest facilities, and open space purchases, among others. The committee has published a guide for the public, with a complete map of the Byway corridor, a Delaware River Water Trail map, a listing of valuable resources, and a calendar of annual events.

The factories and mills of the Revolutionary War and Industrial Revolution have been transformed into art galleries, studios, restaurants, and shops, but the river towns retain most of the early buildings of the Federal and Victorian eras, lovingly restored. Whether one is a history buff, a patron of the arts, a Revolutionary War enthusiast, or simply looking for a good walk, the Byway, with its parallel threads—river, road, canal, and railpath—can provide an unforgettable experience.

One

The Route of the Road

Byway: a scenic road that yields access to special places; to unique cultural, historic, and natural features; and offers a special travel experience for residents and visitors.

The Delaware River Scenic Byway corridor consists of New Jersey State Highway 29 and its right-of-way from Frenchtown in the north to Trenton at the southern end. It includes everything that can be seen from the roadway, and accommodates bicycle and pedestrian as well as vehicular traffic.

Rivers naturally seek the easiest route through terrain. It is no accident that Lenape trails paralleled the river, nor that early dirt roads for coaches and farm carts utilized the same corridor. Dusty cartways connected river town to river town as they grew up around commercial enterprises, and developed into thriving centers dotting the rural landscape along the river. Below Lambertville, parts of the Byway were built in the late 1700s when the United States was a brand new country, undoubtedly along a preexisting Lenape trail.

Route 29, as originally conceived, did not parallel the river. In 1927 plans, the route turned inland to Ringoes, Sommerville, and Newark at Lambertville. The river road from Lambertville to Frenchtown was 29A, and was also known as the Delaware River Drive. Sections of this cartway dated from 1915 and 1916, in the very early days of the automobile.

Though extensive upgrading, tunnel building, and cloverleaf construction took place near Trenton and the river crossings of Interstate 95 and US Route 202 in the 1950s, sections of the river road were still very rural. Between Stockton and Raven Rock, a section was improved in 1951. North of Raven Rock, the "missing link" of River Road was modernized only in 1960. It is still considered a rural road along these stretches, traveling, as it does, the narrow corridor between the canal and the high river bluffs overlooking the Delaware. From Lambertville north, the traveler can imagine being back a century or two, accompanied along the Byway by the canal, the railpath, and the river.

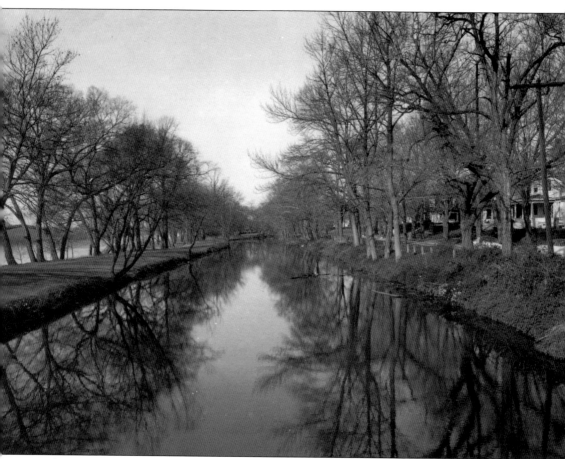

The Trenton Delaware Falls Company, incorporated in 1831, was authorized by the State of New Jersey to build both a structure in the river to focus water into a raceway, and the raceway itself, to carry water to the city of Trenton. The main raceway, shown here in 1955, was 60 feet wide and 6 feet deep. It could generate hydropower with a total fall of 18 feet. From it the city drew drinking water, and a few mills used it as a source of production power into the Victorian Era. (NJDOT.)

The Trenton Water Power was a man-made, seven-mile-long canal completed in early 1932 to encourage industrial development along the Trenton waterfront. It drew water from the river at Scudder Falls, and emptied back into the river below the fall line, which marks the division between the Piedmont Plateau and Coastal Plain. (NJDOT.)

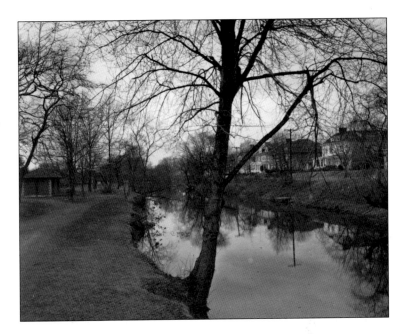

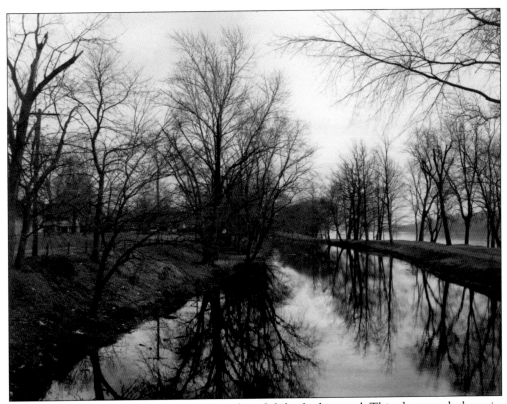

Trenton Water Power lay closer to the river than did the feeder canal. This photograph shows its proximity to the river, still tree-lined in 1955. (NJDOT.)

Before the building of the East-West Freeway, later the John Fitch Parkway, the road that became the beginning of the Byway was lined with trees and a man-made canal. Homes lined the road on the eastern (non-river) side, with access to the waterway; a few owners even built small docks for their own use. To build the parkway, it was necessary to fill in the waterway. The houses lost their waterfront views and the park-like atmosphere of the former narrow road. (Both, NJDOT.)

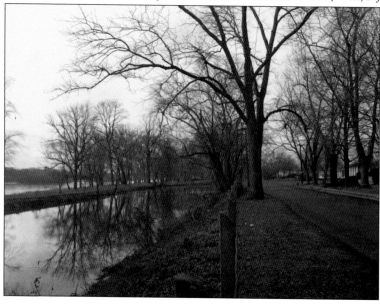

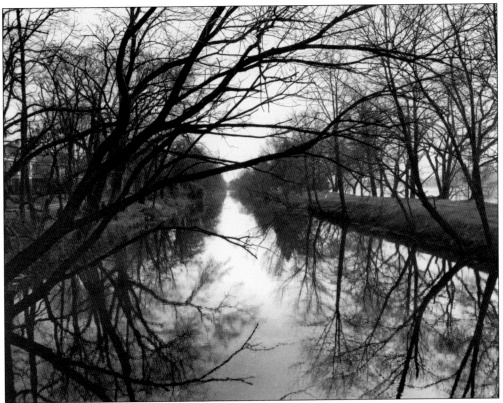

Benjamin Wright (1760–1842), the chief engineer of the Erie Canal (1825) also engineered the Trenton Water Power. The economic success of the Erie was the stimulus for the building of both the Water Power and the Delaware and Raritan Canals. Below, the beautiful and expensive homes along the route of the proposed freeway are reflected in the calm flow of the waterway prior to the building of the freeway that became Route 29. (Both, NJDOT.)

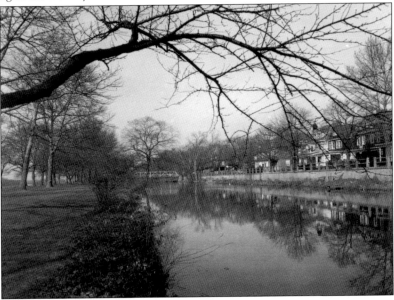

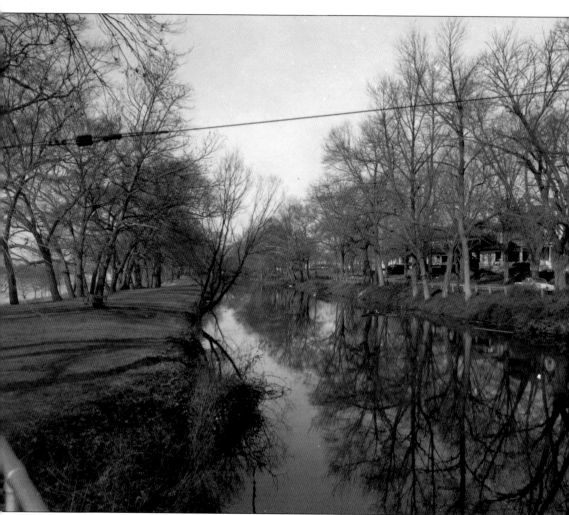

Little remains today to show where the canal was. A small portion was incorporated into what is called Sanhican Creek, which flows through the remains of Stacy Park, half of which was sacrificed to the planned freeway. The mills along its course have long been demolished. An interpretive marker in South Riverwalk Park tells the story of the Waterpower and its contributions to the pre-coal industrialization of Trenton. (NJDOT.)

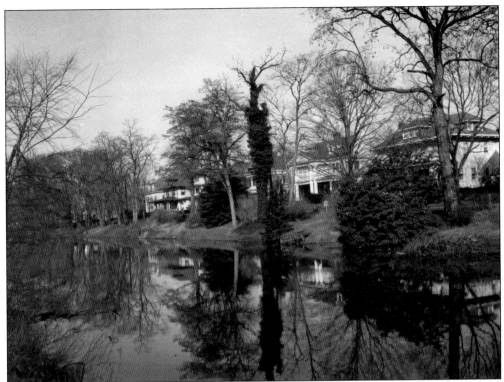

These stately homes of well-to-do middle class families were built in the late 19th and early 20th centuries. The Waterpower they face exists today only as a remnant called the Log Basin in what remains of Stacy Park. (Both, NJDOT.)

In the above photograph from 1956, an old factory stands along the route of the freeway. The image below shows traffic on the freeway leaving Trenton. (Both, NJDOT.)

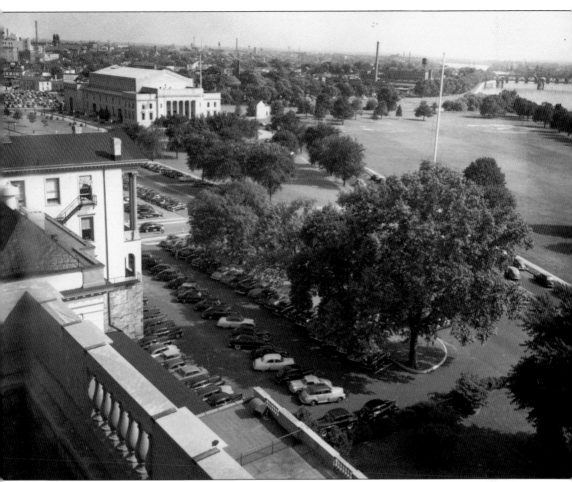

This is a rear view of the state capitol building from the roof of the state annex building, looking south to the War Memorial building, the Delaware River, and two bridges, the famous "Trenton Makes, the World Takes" bridge and the railroad bridge. (NJDOT.)

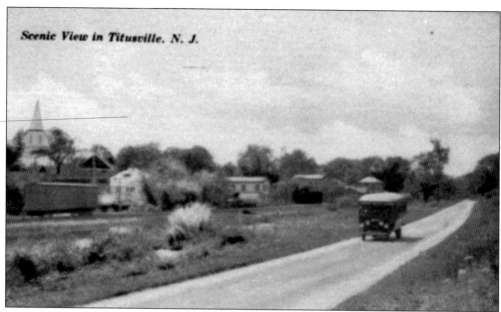

Scenic View in Titusville, N. J.

This 1920 postcard of River Road in Titusville, New Jersey, reveals the rural nature of the Byway at that time. Note the railroad running parallel to the road and the church steeple, which can still be seen today. (NJDOT.)

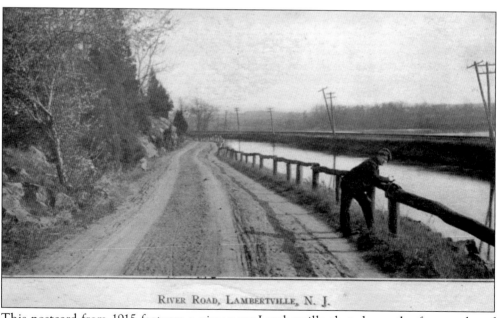

RIVER ROAD, LAMBERTVILLE, N. J.

This postcard from 1915 features a view near Lumberville that shows the four modes of transportation the Byway offers: roadway, canal, rail line, and bridges. (Delaware and Raritan Canal Commission.)

This old brick building south of Lambertville housed the Towle Lace Works, which along with many other mills and factories provided employment for hundreds of local residents. For a time in the 1950s and 1960s, it housed an outlet store for laces, trims, and other dressmaker findings. This photograph shows the condition of Route 29 in 1969 before the extensive improvements on the four-lane divided highway skirting the city center. The building today houses an art gallery, spa, many offices, and the Bucks County Fencing Academy. (NJDOT.)

Between Stockton and Raven Rock, a portion of the Delaware River Drive was completed in 1951. It is labelled on this cold January photograph as the "newly completed section." Raven Rock was a brownstone quarry town, long isolated in its early days with no road running north to Frenchtown or south to Stockton. In 1854, the Belvidere Delaware Railroad was completed with a Raven Rock station at the entrance to Bull's Island. (NJDOT.)

This view looking south along the "missing link" was photographed following completion of the improved road. (NJDOT.)

Even in the late 1950s, Route 29 north of Raven Rock was barely more than a gravel cartway. The final piece of unimproved highway from Raven Rock north to Frenchtown was called the missing link. As was customary at the time, houses were built close to the road, as seen here looking south. (NJDOT.)

March 1960 saw the completion of the missing link. Engineers of the new Route 29 had tried to avoid putting the road on the doorsteps of the houses in Raven Rock while not deviating too far from the old roadway. (NJDOT.)

This portion of the missing link lies north of Raven Rock. Today, the scenery looks very much the same. Trees and farm fields line the highway all the way to Frenchtown, and traffic, except on weekends, is minimal. Wildflowers bloom along the roadsides, and in places, the trees meet overhead. Cyclists enjoy the broad paved shoulders, and the ability to hop on and off the multiuse canal trail at one of its access points. (NJDOT.)

Construction on the missing link is complete in this view to the south. (NJDOT.)

The old road and the new are side by side in this photograph looking south. (NJDOT.)

The new road followed the curves of the river along the black rock cliffs that gave the community its name. (NJDOT.)

This view today is almost identical. The river, however, is nearly obscured by the trees, now 50 years older. (NJDOT.)

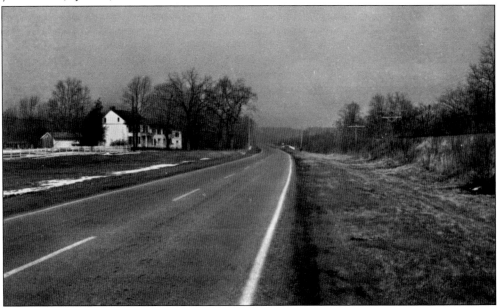

South of Raven Rock toward Stockton, this farm house is still standing and looks very much the same. (NJDOT.)

The last section of the missing link, this unpaved country road close to Frenchtown along the river was taken over by the highway department in 1953 to become the final segment of Route 29. Note the grass growing down the center of the road. (NJDOT.)

Legislative and funding problems delayed improvements to this section. A Citizen's Committee for the Completion of Route 29 mounted an art show to generate interest in improving the road. Prestigious exhibitions included John Folinsbee, Kenneth Nunamaker, Edward Redfield, and Daniel Garber. This was Garber's last exhibit as a living artist. (NJDOT.)

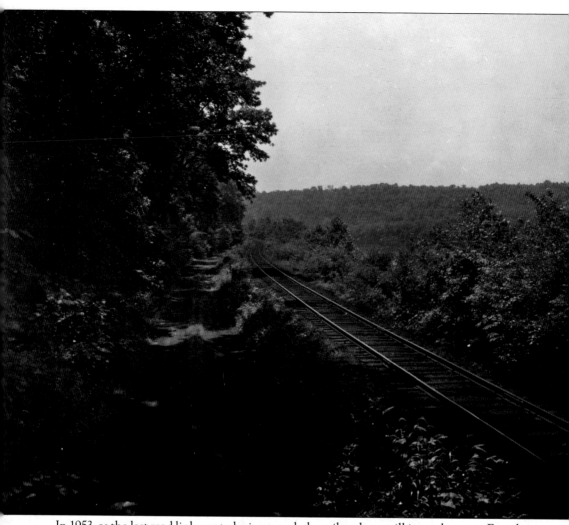

In 1953, as the last road link was to be improved, the railroad was still in use between Frenchtown and Stockton. (NJDOT.)

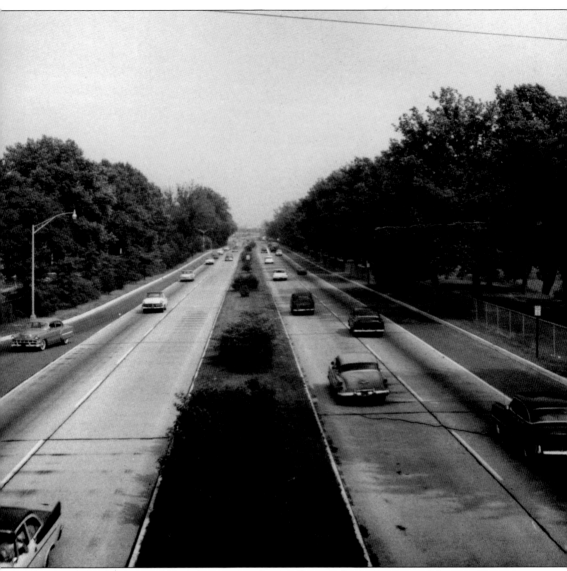

The four-lane divided East-West Freeway with its light, steady traffic pictured here in Trenton provided a distinct contrast to the very rural section of the road near Raven Rock with scarce traffic near the northern end of Route 29. (NJDOT.)

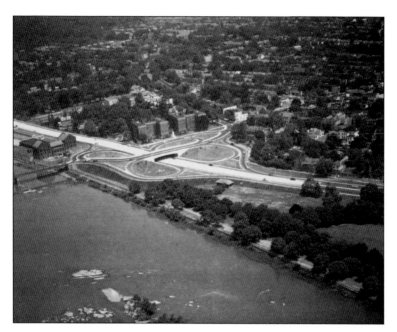

The Calhoun Street cloverleaf provides access from Route 29 to the office buildings of the New Jersey Capitol Complex. (NJDOT.)

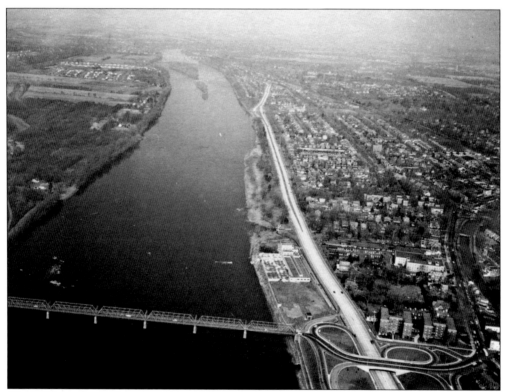

This 1957 aerial view shows the Calhoun Street Bridge from Morrisville, Pennsylvania, approaching the cloverleaf leading to West State Street, the downtown state capitol buildings, and the Trenton Water Works. (NJDOT.)

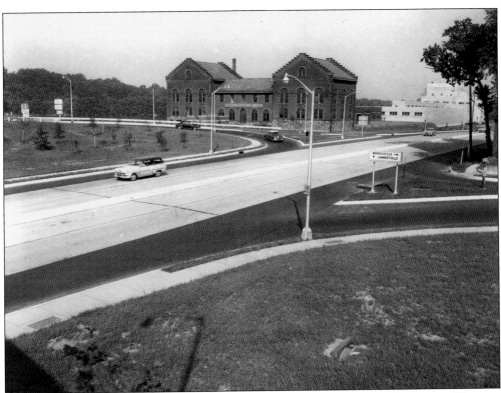

At this intersection with the freeway of the Calhoun Street overpass with the Trenton Filtration Works brick building, the signs point to Morrisville, Pennsylvania, and Lambertville, New Jersey. (NJDOT.)

In this closer aerial view of the Calhoun Street cloverleaf looking east from West State Street, the corner of the right hand side will become the site of the New Jersey Council of the Arts building. Farther to the right are the grounds of the New Jersey State Museum complex. (NJDOT.)

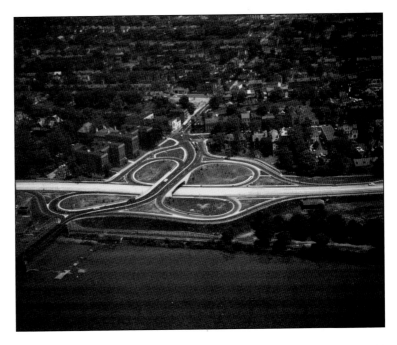

31

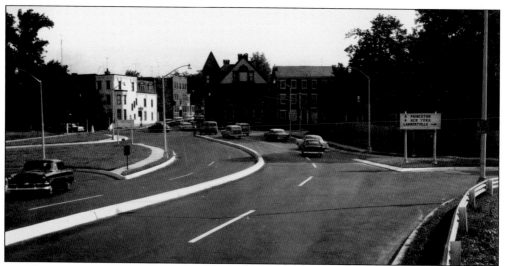

Traveling east on the freeway from the intersection of Route 29 and Calhoun Street, it is possible to head for Princeton and New York City. (NJDOT.)

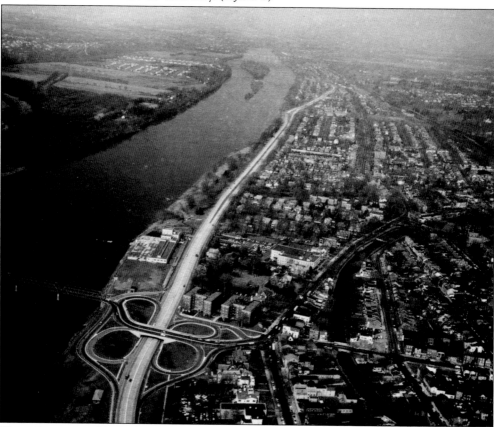

This extreme aerial long shot from 1956 looks north toward the future site of the Scudder Falls Bridge and the connection of Interstate 95 leading into New Jersey from Pennsylvania. The Delaware and Raritan Canal lies to the right of the Calhoun Street cloverleaf. As it heads north out of Trenton, the canal returns to its parallel position next to the river and the Byway. (NJDOT.)

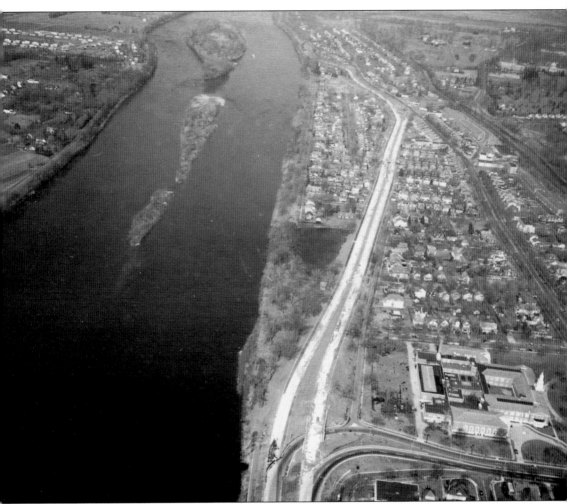

In 1957, the Parkside access to Route 29 was under construction. Note the canal to the right and just north of Trenton City Junior High School Three. (NJDOT.)

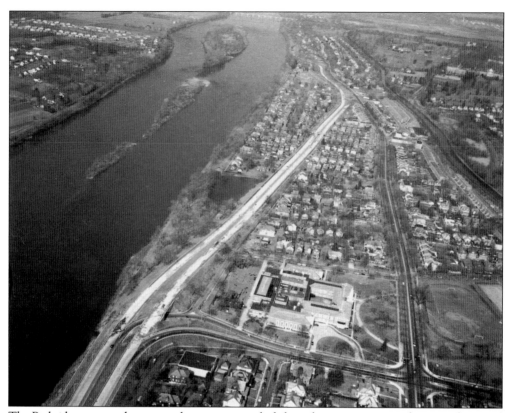

The Parkside access and access to the previous road while under construction is shown in this aerial view from the New Jersey Department of Transportation. The canal is to the right. (NJDOT.)

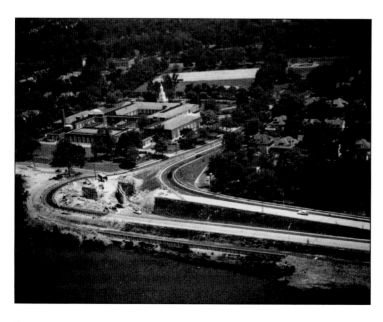

In June 1956, construction of the Parkside Bridge exit and entrance to Route 29 had progressed this far. The junior high is at the intersection of Parkside Avenue and West State Street; this intersection is identical today. (NJDOT.)

This 1958 close-up shows the completed overpass for the Parkside Avenue access to the new Route 29, the John Fitch Parkway. (NJDOT.)

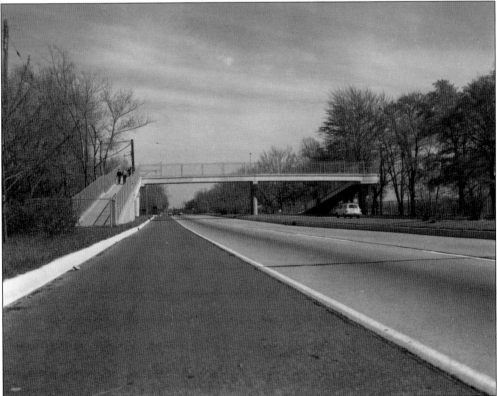

In 1960, a pedestrian overpass was built to reestablish easy access to the Delaware River and park for the neighborhood of large family homes that face the new Route 29, John Fitch Parkway. Looking south toward the downtown state capitol area, note the Delaware River on the right. (NJDOT.)

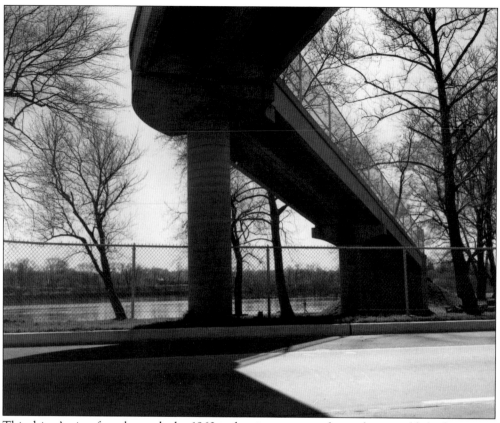

This driver's view from beneath the 1960 pedestrian overpass shows the reestablished access to the river and riverside park walking paths. Note the person walking along the riverbank and the Pennsylvania shoreline on the far side of the Delaware. Later, the pedestrian overpass was completely caged to make it compliant with revised safety laws for pedestrians and motorists. (NJDOT.)

This view toward the marginal road along West State Street shows an old Esso station in 1961. Later, Esso became Exxon; the station is now gone. (NJDOT.)

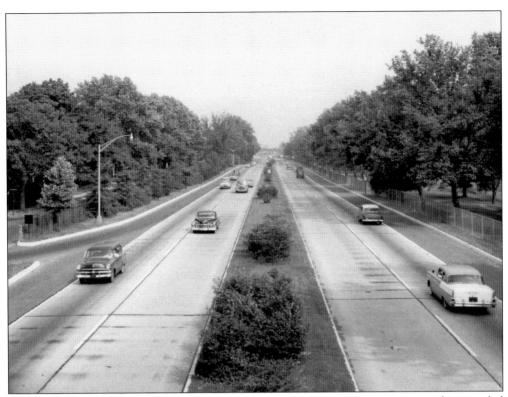

One of the fun aspects of looking at old road pictures is spotting the vintage cars that traveled them. In the lower right of this image is a 1957 Chevrolet with its distinctive tail fins. It was the first automobile available with tubeless tires and is one of the most popular models among vintage car buffs. (NJDOT.)

This image, along with the next two, are views from 1965. This looks west toward the river. All three show how the proposed link of the John Fitch Parkway would be changed to remain along the river, removing the loop through the capitol complex. (NJDOT.)

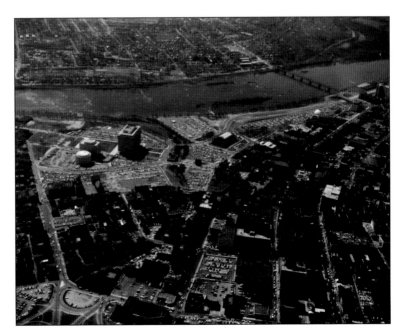

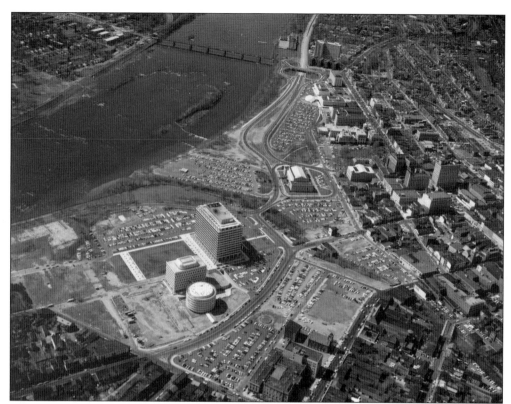

These two 1965 photographs look toward the north. The images demonstrate the major reconstruction and revitalization that Trenton underwent from 1950 through 1965. The former slaughterhouse and meatpacking district was completely redeveloped. Access to this area today is from the Market Street exit of the Byway. (Both, NJDOT.)

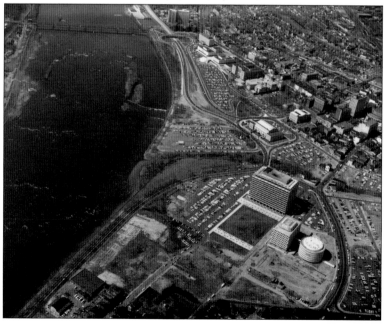

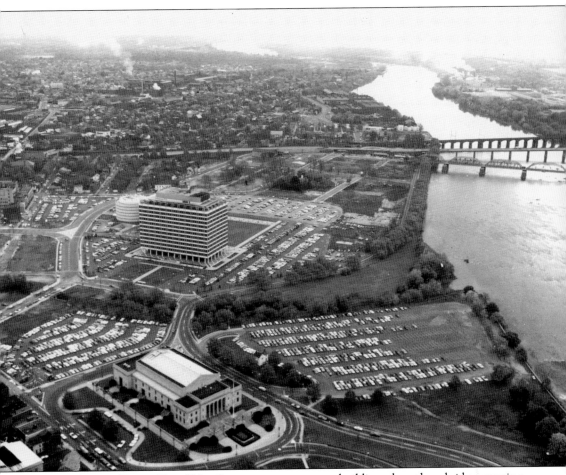

This aerial view of Route 29 and New Jersey state government buildings show three bridges crossing the widest part of the non-tidal stretch of the Delaware River. The Warren Street Bridge ("Trenton Makes" bridge), Route 1 Bridge, and the West Trenton Railroad Bridge. (NJDOT.)

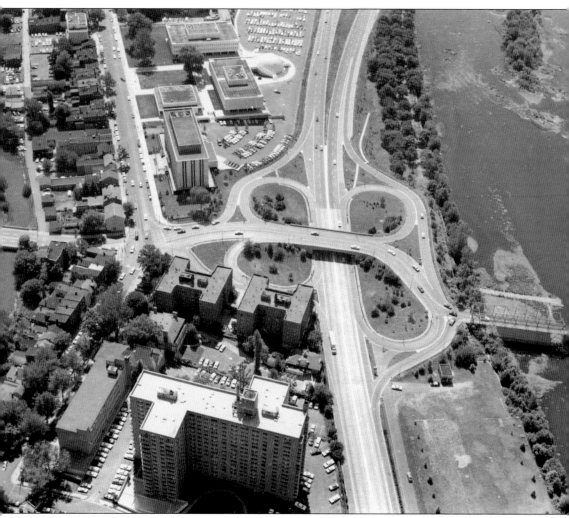

This 1965 view of the Calhoun Street cloverleaf shows the extent of revitalization that Trenton experienced after the completion of the Route 29 Parkway. It shows the new New Jersey Council of the Arts building, the state museum, planetarium, and state library. Directly across the street, a row of historic brownstone buildings remain untouched and preserved. Compare this with the previous photographs of the same intersection in 1956 to see the dramatic difference. (NJDOT.)

Two

THE RIVER, THE CANAL, AND THE RAILROAD

First came the river. Old in geologic time, it carved the broad valley from soft shales, leaving bluffs and cliffs on either side. Sacred to the Lenape and vital to early colonials, the river today is an important recreational resource, a source of good drinking water for 15 million people, and home to some exceptional plant and animal life.

Thirty-nine river miles along the Byway and 28 miles of tributaries became a National Wild and Scenic River in November 2000, joining the upper and middle segments designated earlier. Less than one quarter of one percent of US rivers have this designation.

Just as the Lenape did, early colonists used the river for travel, water, food, and later, power. As the wheels of the Industrial Revolution began to turn in Trenton, Philadelphia, and New York, and with early forms of river transport proving capricious, attention turned to a calmer, safer way to move goods and raw materials along the corridor.

Canal construction began in 1930. Migrant Irishmen dug (mostly by hand) the main canal and the feeder along the Byway, which was built to supply water to the high point of the canal in Trenton. Mule teams and steam tugboats moved freight up and down this 22-mile-long, 50-foot-wide, 6-foot-deep waterway.

During the peak years, the 1860s and 1870s, 80 percent of the cargo was coal from Pennsylvania heading for the flourishing industrial cities. Eighteen ninety-two was the last profitable year of operation, however, as the railroad proved to be a more efficient form of transportation.

Chartered in 1836, the Belvidere Delaware (BelDel) opened between Trenton and Lambertville in 1851, and tracks reached Belvidere in 1855. Steam locomotives carried anthracite coal formerly carried by canal boats. Usage faded, and diesel Doodlebugs replaced steam engines by the 1950s.

The ultimate owner of the line had no use for the BelDel after 1978, since there was little industry left in the valley. The final train ran in November of that year. Between 1979 and 1982 Conrail dismantled the tracks, and the right-of-way became the D&R Canal Trail.

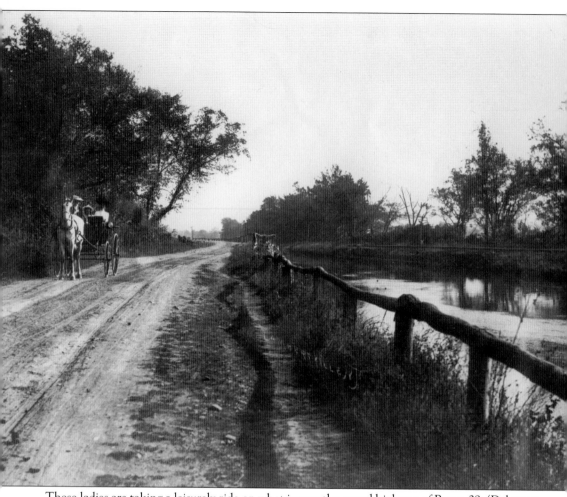

These ladies are taking a leisurely ride on what is now the paved highway of Route 29. (Delaware and Raritan Canal Commission.)

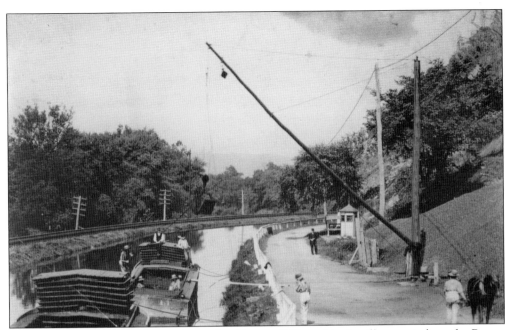

The Mercer County Workhouse, located in Hopewell Township, is still present along the Byway today. The boats pictured here are being loaded with goods while the mule takes a much-needed break. (Delaware and Raritan Canal Commission.)

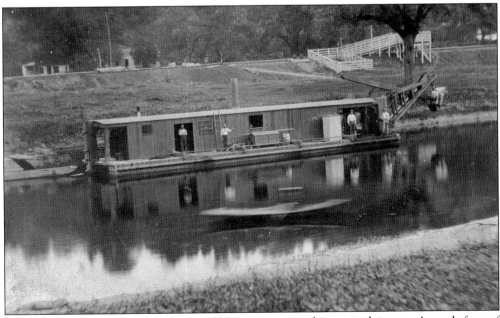

This image of the canal boat known as *Old Digger* is a copy of an original tintype. An early form of "instant" photography, the tintype did not use negatives like later film cameras. Instead, a positive image was applied to a thin piece of metal and was ready within minutes of the photograph being taken. Interestingly enough, no tin was used in the process. (Carl Cathers.)

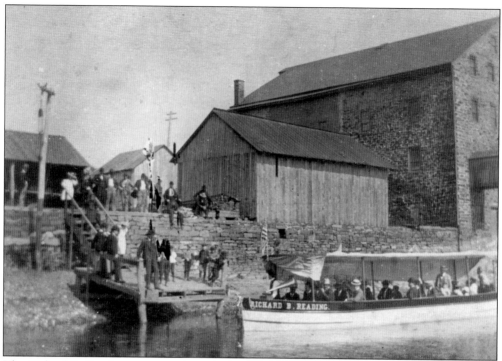

The *Richard B. Reading* passenger boat docks near the Lear Mill in Lambertville, New Jersey, providing a base for boarding and disembarking. The wooden structure protruding from the second floor of the building at right was known as a "Chic Sale." Charles "Chic" Sale was a vaudevillian famous for having written a play about an outhouse builder, which resulted in his name becoming a euphemism for outhouses. (Carl Cathers.)

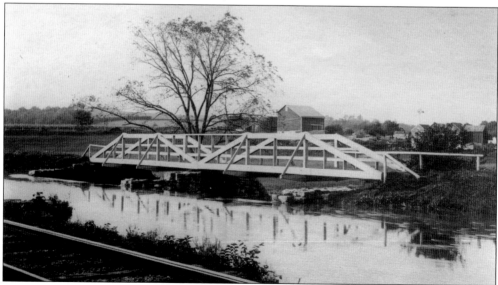

This undated photograph shows an overflow located near Lambertville. Like the spillway next to the Prallsville Mills, the purpose of the overflow is to regulate the water level of the canal. The bridge over the overflow is for the mules pulling the boats. (Delaware and Raritan Canal Commission.)

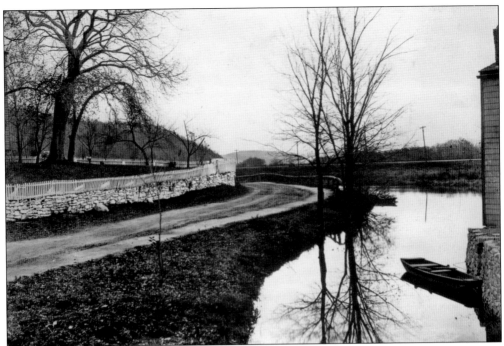

This view shows the D&R Canal and Route 29 at Brookville, just south of Stockton. Brookville Hollow is one of only a few streams allowed to flow directly into the D&R canal. (Delaware and Raritan Canal Commission.)

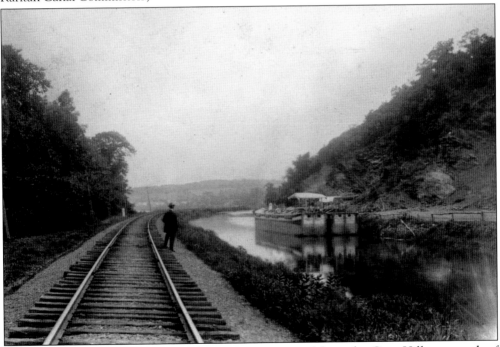

Canal boats are being loaded with brownstones quarried from the Goat Hill area south of Lambertville. Brownstones from Goat Hill were used to help construct the famous brownstones of New York City and Philadelphia. (Delaware and Raritan Canal Commission.)

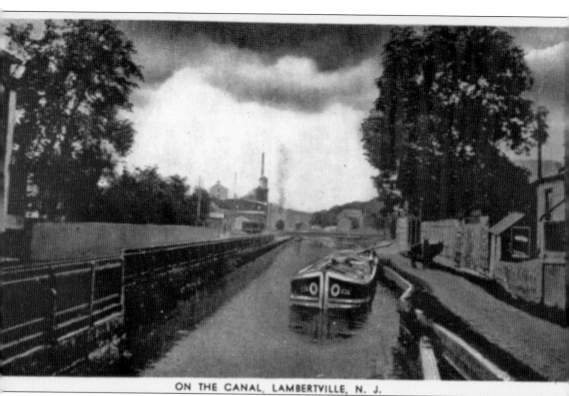

ON THE CANAL, LAMBERTVILLE, N. J.

This postcard shows a canal boat on the canal in Lambertville. Two mules, patiently waiting, do not seem to be disturbed by the train puffing away on the opposite side of the canal. (NJDOT.)

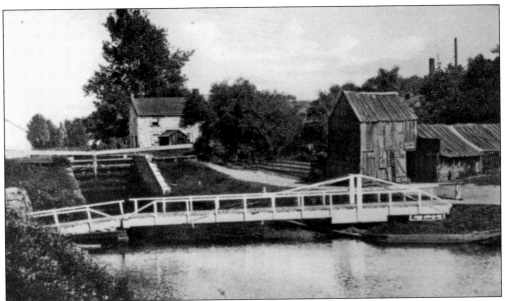

The Lambertville Lock was the only lift lock along the feeder canal of the Delaware River. The locktender's house is to the right of the lock. (Delaware and Raritan Canal Commission.)

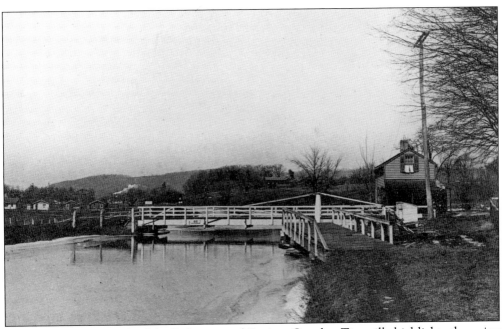

This c. 1900 photograph of the Delaware and Raritan Canal at Titusville highlights the swing bridge and the bridgetender's house to the right of the bridge. The bridgetender was an employee of the canal company and received a salary along with lodging. The house was built in the 1830s. (Delaware and Raritan Canal Commission.)

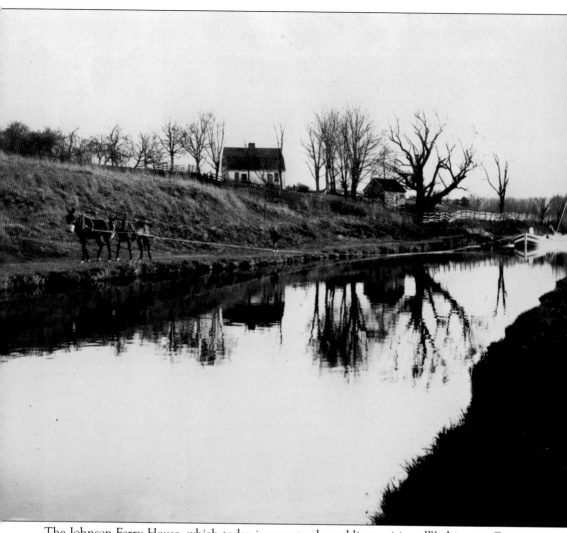

The Johnson Ferry House, which today is open to the public to visit at Washington Crossing State Park, overlooks a mule-drawn canal boat on the D&R Canal. (Delaware and Raritan Canal Commission.)

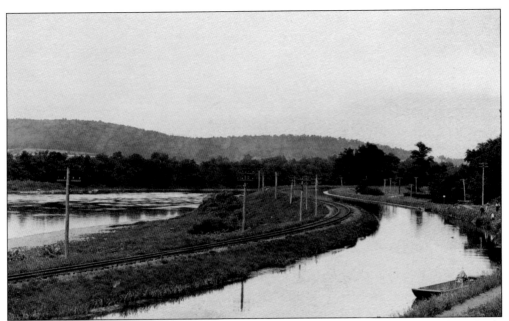

This photograph of a meandering canal hugging the shape of the river north of Titusville perfectly demonstrates how the D&R Canal was constructed as a contour canal. (Delaware and Raritan Canal Commission.)

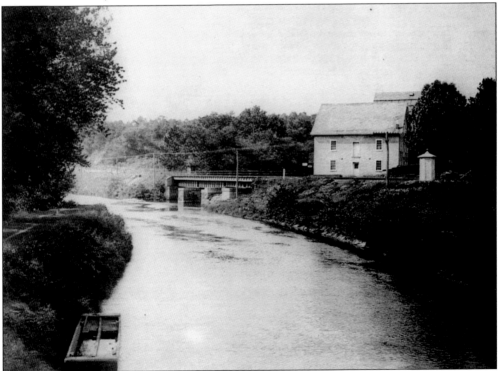

Lock tender George Price's boat can be seen in the lower left in this pre-1936 view of the feeder canal. He operated the boat by pushing a long pole to the canal floor while standing at the front of the boat and then walking to the back to propel it forward. (Delaware River Mill Society.)

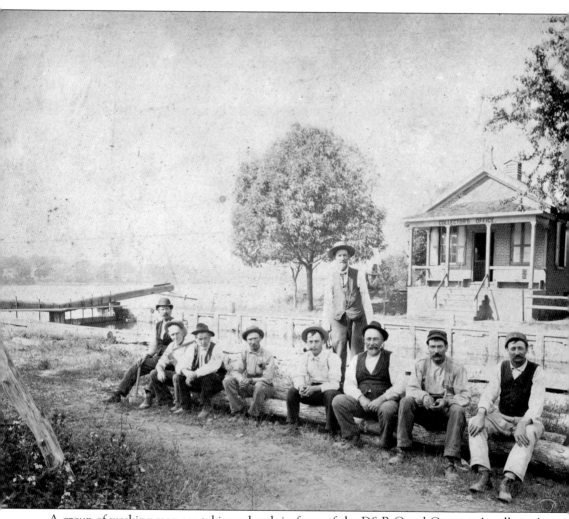

A group of working men are taking a break in front of the D&R Canal Company's collector's office at the Outlet Lock in Lambertville. A cable ferry was installed across the Delaware River when this lock was added to the feeder canal in 1847 to aid the transport of canal boats from Lambertville and New Hope. Today, the remnants of the outlet are still visible. (Lambertville Historical Society.)

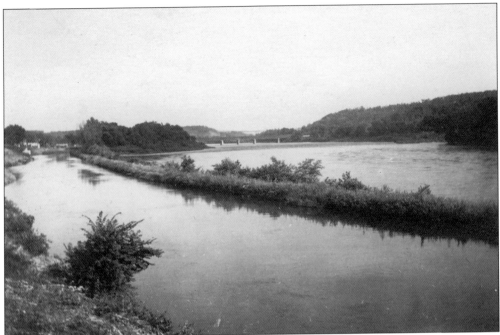

This c. 1920 photograph is looking south to the Stockton Bridge across the Delaware River. The feeder canal of the Delaware and Raritan Canal flows along the left of the river on the New Jersey side. For the most part, the canal is 60 feet wide at the top and 6 feet deep. The feeder canal was only navigable by the mule-drawn boats. (Carl Cathers.)

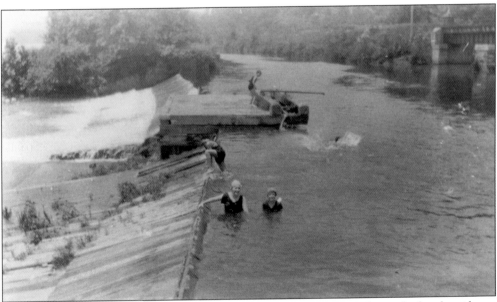

Long before it became a state park, the canal served as a recreational area for local residents. The structure in the middle housed the control gates for the canal, which could be used to drain water from it if necessary. Known by the residents as the "stone box," it was a popular swimming and gathering place during the warm summer months. (Carl Cathers.)

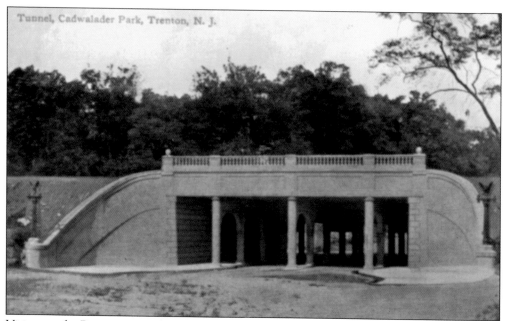

Visitors to the Byway can see the aqueduct of the D&R Canal directly off Route 29 at Cadwalder Park in Trenton. Cadwalder Park was designed by Frederick Olmsted, the famous designer of Central Park in New York, and is the oldest greenway in Trenton. Aqueducts allow the canal water to flow as traffic drives underneath. (Delaware and Raritan Canal Commission.)

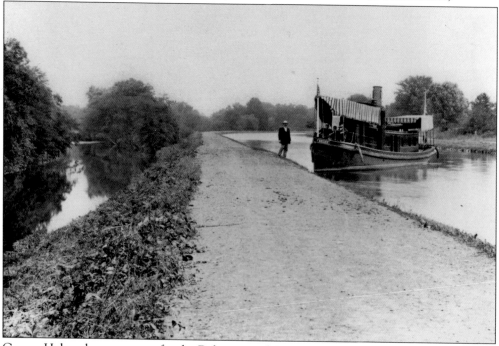

George Holcombe, paymaster for the Delaware and Raritan Canal, chats with the crew of the *Relief*, which served to break up ice that formed on the canal as the weather got colder. Eventually, the canal would be partially drained for the winter, providing opportunities for winter recreation but not much transportation. (Delaware and Raritan Canal Commission.)

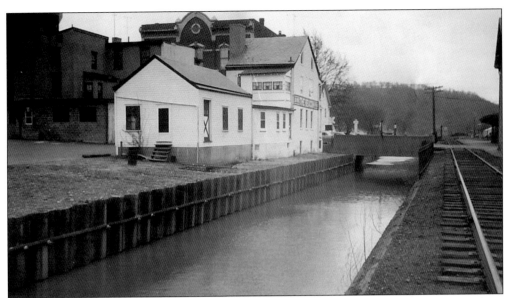

This Polaroid picture from the 1960s shows the offices of the *Beacon*, a long-running newspaper of Lambertville that was located along Bridge Street near the Delaware and Raritan Canal. The *Beacon* is still in print today, providing residents with local news. A multiuse path has been added to the small stretch of land between the buildings and canal throughout Lambertville, providing visitors with a unique walking experience. (Lambertville Historic Society.)

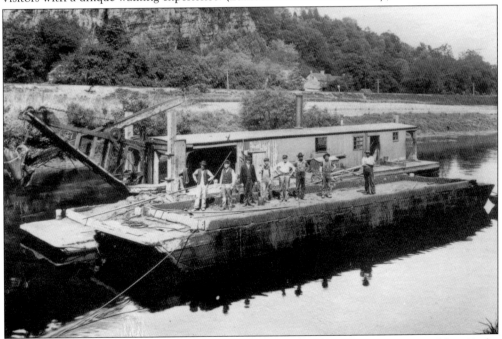

This workboat crew dredged the canal to keep silt from building up, a common problem in the feeder canal. Dory Wilson, who would eventually become the lock tender at the Prallsville Lock, stands at the front left of the boat known as *Old Digger*. Wooden timbers were driven into the floor of the canal to stabilize the boat during the dredging operation. (Delaware and Raritan Canal Commission.)

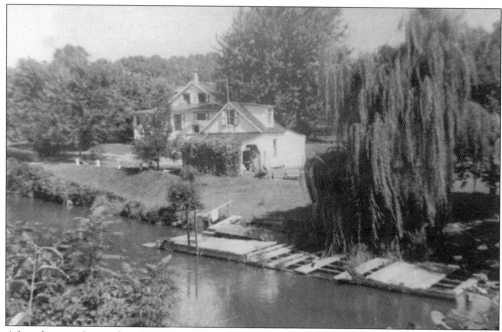

After the canal was abandoned in 1933, *Old Digger* was also abandoned and floated down the canal in order to clear the lock area. The wood from the old dredger was salvaged by locals, leaving only the deck floating in the canal as seen here under the weeping willow tree. It remained there until 1955, when it was washed away by the flood from Hurricane Diane. (Carl Cathers.)

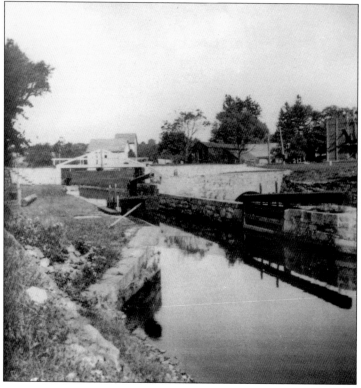

The Delaware and Raritan Canal originated at Bull's Island and continued to Trenton. Navigable along its entire course, it had only three locks. This is the Prallsville Lock, with the gristmill and silo visible in the distance. On the right is the stone crusher, which was only in use for a short time and dates this picture to the 1920s. (Delaware and Raritan Canal Commission.)

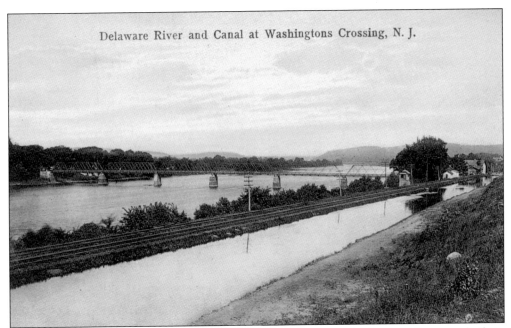

Delaware River and Canal at Washingtons Crossing, N. J.

Looking north at Washington Crossing, the double woven truss bridge seen here was built in 1904 and is still in use today connecting the Pennsylvania and New Jersey Washing Crossing Parks. (Delaware and Raritan Canal Commission.)

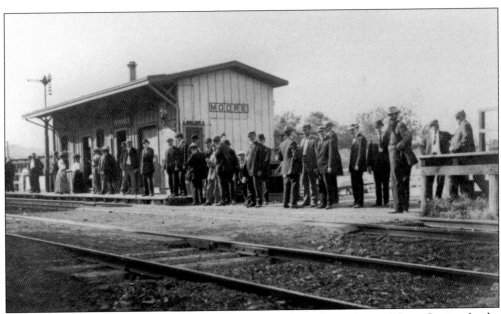

At the west end of Pleasant Valley Road and River Road was the two-room Moore Station for the Bel Del Line of the Pennsylvania Railroad Company. Patrons could take this line south toward Trenton or north to Phillipsburg. (Delaware and Raritan Canal Commission.)

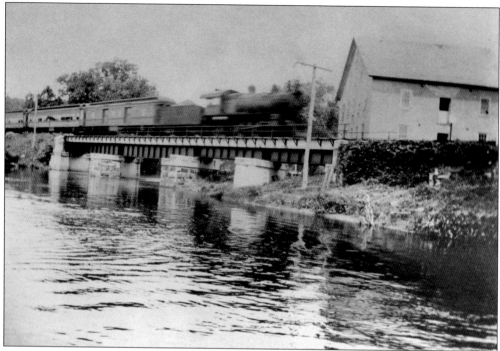

This c. 1920s photograph shows the midday passenger train rushing past the Prallsville Mill. Steam locomotives threw hot cinders and ash into the air as they passed close by the mill buildings. In an effort to protect the buildings from fire, the roofs as well as the sides of the silo were covered with metal siding. (Carl Cathers.)

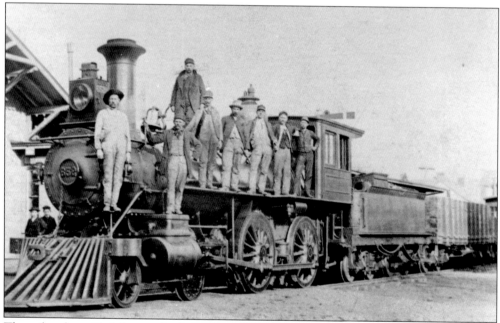

The railroad provided thousands of jobs. Here, the crew of a steam locomotive poses for a picture. Life on the railroad was hard, yet its stories were highlighted with hobos and other colorful people and folklore. (Delaware and Raritan Canal Commission.)

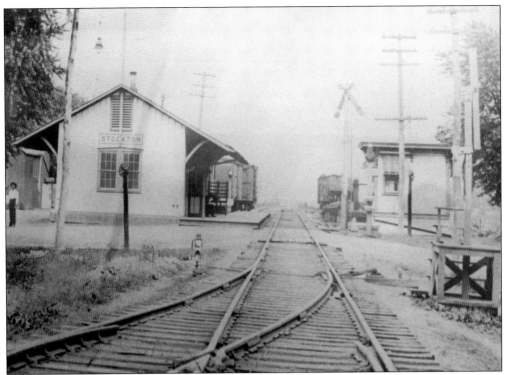

This c. 1895 photograph shows the Stockton train station looking south across Bridge Street. The rails that split off to the left are for a siding where the freight trains could wait and let the passenger trains pass by. Today, the station building houses a deli and general store. (Delaware River Mill Society.)

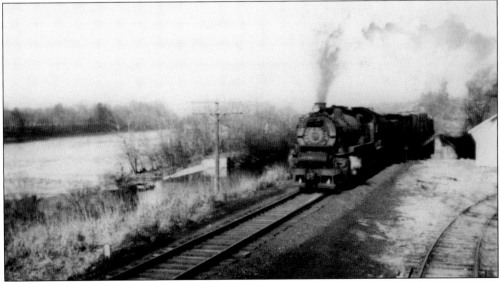

Freight train No. BL5, pulled by engine No. 1537 on the BelDel line of the Pennsylvania Railroad, passes the Prallsville Mill as it heads south from Phillipsburg on its way to Wilmington, Delaware. The photograph was taken in early 1950 by Frank Barry while he stood on a boxcar on the siding by the sawmill. (Carl Cathers; photograph by Frank Barry.)

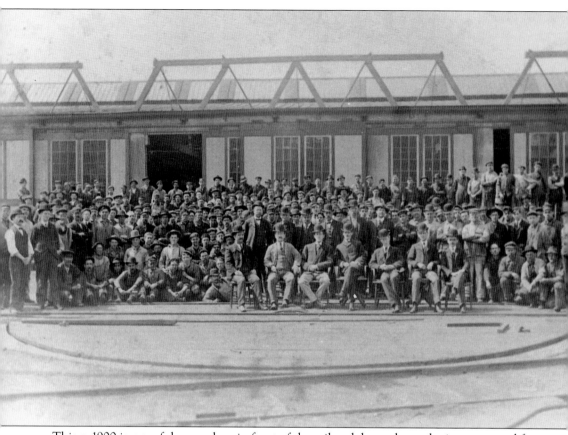

This c. 1900 image of shop workers in front of the railroad depot shows the immense workforce required for the Bel Del Railroad to maintain its operations. The Lambertville Station opened up to trains in 1851 and the railroad line was completed up to Belvidere in 1855. Today, Byway visitors can partake in a meal within the walls of the old depot at the Lambertville Station Restaurant. (Lambertville Historic Society.)

During World War II, the Pennsylvania Railroad, like other freight and passenger carriers of the time, focused its resources on the efficient movement of troops and supplies. Coordinated through the Office of Defense Transportation, the railroad's advertisements reinforced the idea that its primary job was not just moving troops, but moving all they required as well. The railroad pointed out that each soldier going overseas required an average of eight tons of freight including ammunition, equipment, food, and supplies. In this 1942 photograph, Army trucks, strapped two to a flatcar with wood chocking around their wheels, are transported through Stockton. (Carl Cathers.)

In this 1960s image, a diesel Bel Del train travels north next to the feeder canal making its way toward the Fireman's Bridge and Lambertville. (Delaware and Raritan Canal Commission.)

Doodlebugs replaced the steam locomotive for passenger travel. In this 1950s photograph, Doodlebug 4669, with a baggage car attached, arrives at Stockton station to pick up northbound passengers. The origin of the name is unclear; however, it may have been taken from the phrase "doodling through town." The last passenger train passed through Stockton on October 24, 1960. (Carl Cathers; photograph by Frank Barry.)

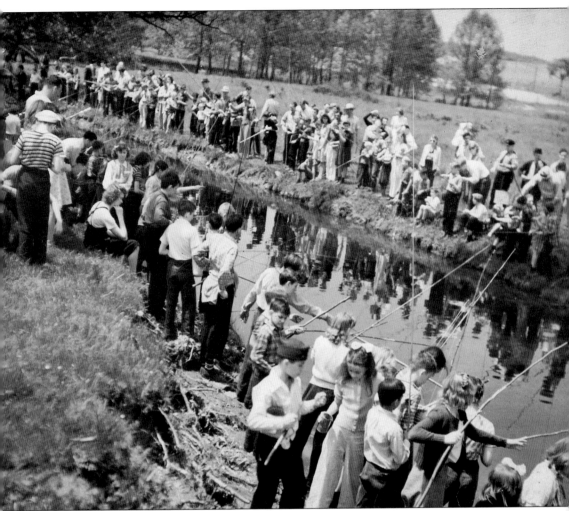

This 1950s image shows a popular fishing derby held in Lambertville. Today, anglers are often seen fishing in the canal and river for a wide variety of fish including bass, shad, crappie, and trout, which are stocked in the canal by New Jersey Fish and Wildlife during the spring. (Lambertville Historical Society.)

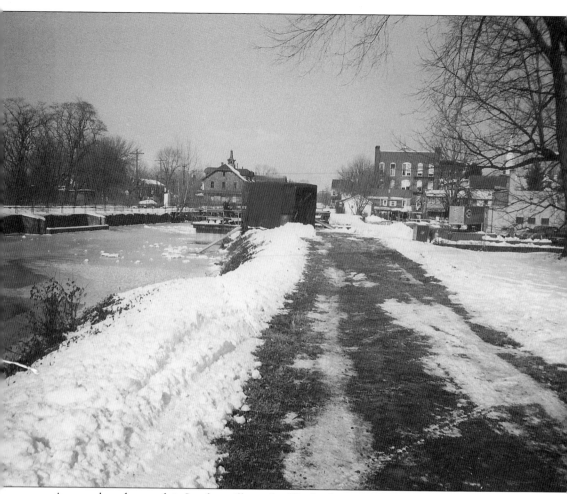

A snow-plowed towpath in Lambertville south of Bridge Street is seen here in the 1980s. Lambertville Station, which by then was repurposed as a popular eating establishment, can be seen to the left of the canal. (Lambertville Historical Society.)

Three

THE BYWAY IN THE PAST

More than 80 historically important features contribute to the Byway. Trenton houses many buildings important to the early days of the country, including the Trent House, Trenton City Museum, Old Barracks Museum, National Guard Militia Museum, the New Jersey State Museum with its modern planetarium, and the French Arms Tavern, where the US Congress sat in 1784 before a new capital was built on the Potomac.

Washington Crossing Park memorializes General Washington's daring crossing of the river on the eve of the Battle of Trenton. The National Museum of the American Revolution and the Johnson Ferry House, where Washington spent that night, are located here.

Farther north, Howell Living History Farm and the Holcombe-Jimison Farmstead demonstrate agricultural practices in the valley from the 18th and 19th centuries. In Lambertville, the 1870 Holcombe House, recently renovated and restored, houses City Hall and is a fine example of French Second Empire architecture.

Outside of Stockton, several mills—grain, wood, and seed—vital to the agricultural economy of the early Delaware Valley, comprise the Prallsville Historic District, which also includes a small museum in the 1794 Prall House. The Wickecheoke Trail, running along the eponymous creek that traverses the 20,000-acre preserved Wickecheoke Greenway, passes through the Prall House yard to meet the Canal Trail at the grist mill. Stockton Boro boasts the oldest public school still in use in the state.

Bull's Island Recreation Area lies north of Stockton. With its walking trails and Natural Areas, it is an Important Birding Area of the National Audubon Society. A Roebling-built pedestrian bridge leads across the river to Lumberville and the Black Bass Hotel, owned and operated by Tories during the Revolutionary War.

The Byway ends in Frenchtown, where 70 houses and buildings from between 1866 and 1870 still stand, amid others dating from the 1820s. These form the Frenchtown Historic District, listed in the National Register of Historic Places in 1994.

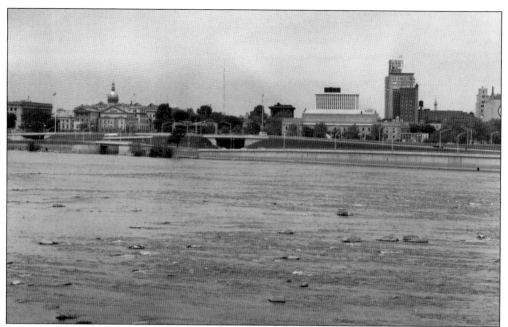

This is a view of the state house complex in 1970 from the opposite side of the river. The photograph shows well how the buildings of the complex relate to each other. (NJDOT.)

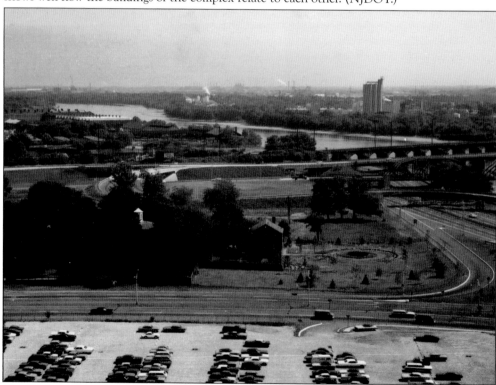

The William Trent House, built in 1719, now houses a museum owned by the City of Trenton. Tours are available of this historic home of the man for whom Trenton is named. Today, it sits across from the William Hughes Justice Complex, built in 1982. (NJDOT.)

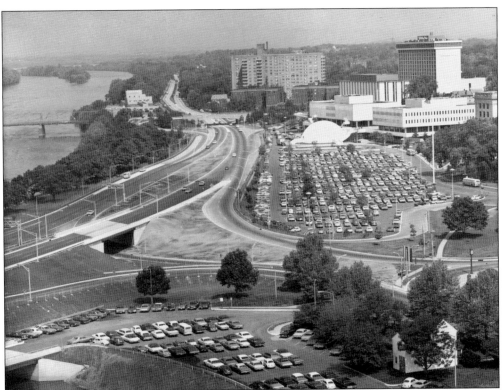

This aerial photograph, taken in 1970 along Route 29, shows a fine view of the planetarium, built as part of a new state museum in 1965. Seating 150 visitors, this largest planetarium in the state has state-of-the-art, full dome video to zoom the visitor through the solar system and beyond. (NJDOT.)

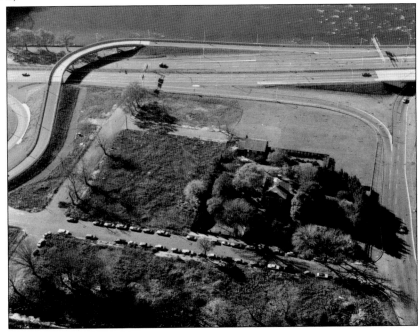

This aerial view shows the Trent house and its surroundings in 1971 with the overpass completed. (NJDOT.)

The kitchen gardens at the Trent House, shown here in the process of construction, were reconstructed in 1972. The house was given by the last private owner to the city under the condition that it be restored to its condition at the time of William Trent. In the background is the large New Jersey State Building Complex, which can be seen from Route 29. (NJDOT.)

This is a 1963 view of the William Trent House on Warren Street. One of the oldest sites on the Byway, this expansive complex was the home of Trenton's leading marine merchant. The depth of the Delaware River in the 1700s allowed large merchant ships to dock on the banks of William Trent's impressive estate. (NJDOT.)

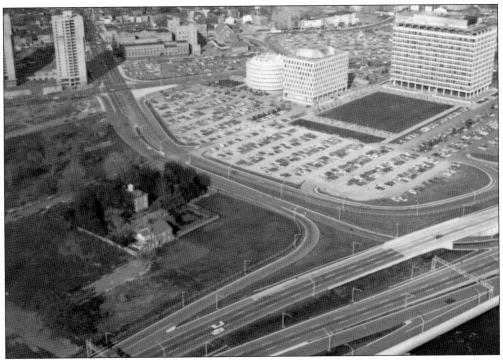

The historic Trent House is dwarfed by the massive freeway in 1971. (NJDOT.)

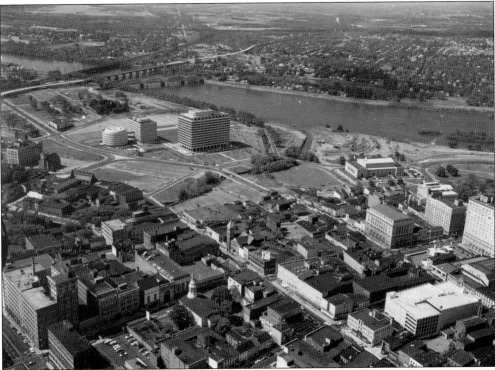

This photograph shows the state building complex as it appeared in 1968 and an aerial view of the three bridges crossing over the Delaware River to Pennsylvania. (NJDOT.)

These photographs, both taken in November 1956, are two views of the Trenton Old Barracks on Front Street, located around the corner from the New Jersey State Capitol on West State Street. The Old Barracks has been more accurately restored, reflecting the true characteristics of the 1758 structure. The site offers programs, demonstrations, and family activities highlighting the significance of this historic site. (NJDOT.)

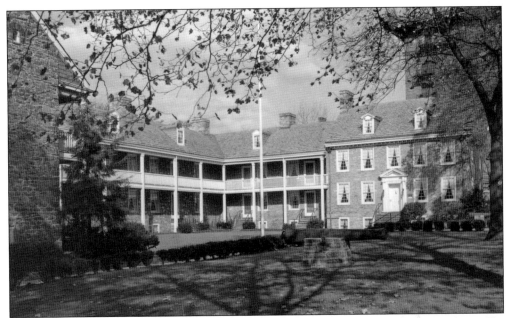

The Old Barracks first housed Hessian mercenary troops, then Washington's soldiers, during the Revolutionary War. (NJDOT.)

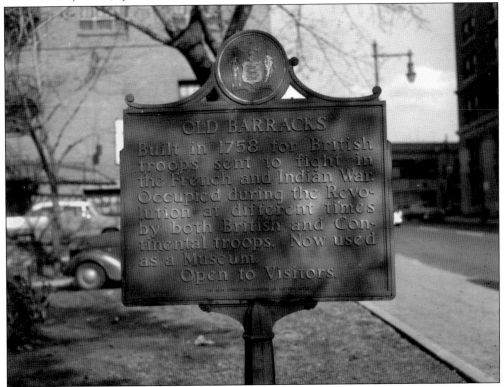

Pictured here is the 1956 Trenton Old Barracks historic marker, which notes that the 1758 structure was built to house British troops during the French and Indian War. The site was occupied at various times by both sides during the Revolution. (NJDOT.)

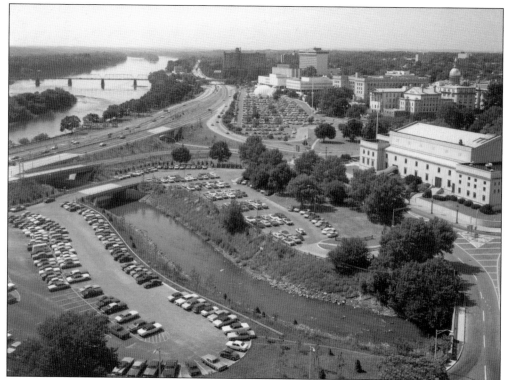

The golden dome of the capitol rises in the background of this view of the state house complex in 1973, and the Assumpink River, which flows into the Delaware River. (NJDOT.)

A rear parking area providing access to the New Jersey State House is shown in 1950. Taken from the roof of the Trenton War Memorial building, this photograph shows the view from the War Memorial roof, giving an idea of the open and relaxed atmosphere of the state capital buildings. It looks north along the current Byway. (NJDOT.)

This 1950 view of the State House shows the expansive nature of the complex, with its long, tree-lined parking lots. (NJDOT.)

This close-up view of the cross street behind the State House was taken on August 30, 1950. (NJDOT.)

This photograph, also taken in 1950, offers a longer view of the street. Note the numerous cars. (NJDOT.)

This is a 1950 street-level view of the State House from the Trenton War Memorial building. (NJDOT.)

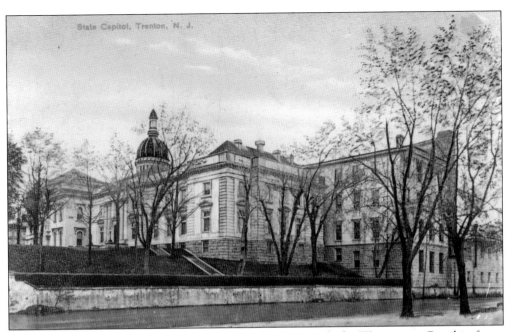

This postcard from 1908 shows the Trenton State House with the Waterpower Canal in front. (New Jersey State Library.)

The Sanborn Map company was founded in 1866, the oldest mapping company in the country. This hand-drawn Sanborn map shows the Capitol building, with the Waterpower Canal, the river, and the feeder canal as it wound through the city to the Delaware and Raritan Canal heading north. (New Jersey State Library.)

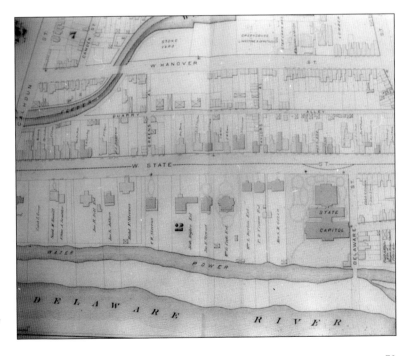

The back of the postcard on the previous page, cancelled in 1908, holds a penny stamp—the origin of the term "penny post card." The card is published by a Trenton company but was made in Germany. (Courtesy New Jersey State Library.)

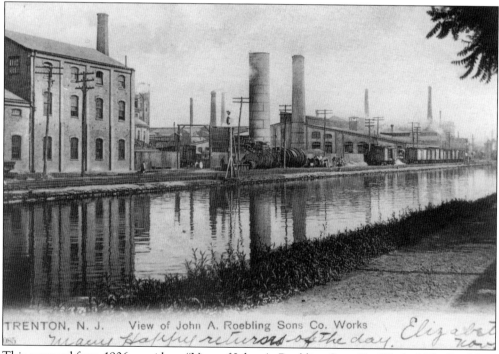

TRENTON, N. J. View of John A. Roebling Sons Co. Works

This postcard from 1906 provides a "View of John A. Roebling Sons Co. Works." The Roebling Works were responsible for the design and construction of the Brooklyn Bridge; the Riegelsville, Pennsylvania, bridge over the Delaware River just north of Frenchtown; and the Bulls Island pedestrian bridge connecting Bulls Island and Lumberville, Pennsylvania. (Carl Cathers.)

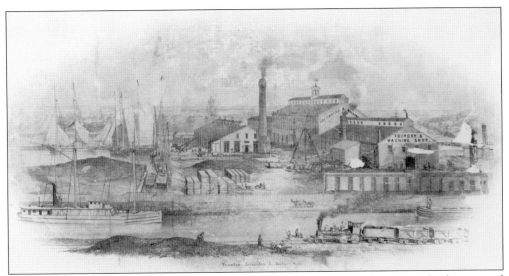

This 1860 engraving of Trenton portrays the city as a hub of manufacturing. (Delaware and Raritan Canal Commission.)

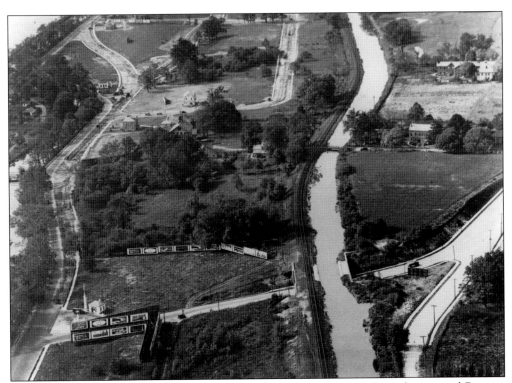

This 1925 aerial view of north Trenton highlights the aqueduct of the Delaware and Raritan Canal at Sullivan Way. (Delaware and Raritan Canal Commission.)

The Washington Crossing State Park, commemorating the December 25, 1776, crossing of the Delaware by the Continental Army and subsequent battle to defeat the Hessian troops in Trenton, is located along the Byway north of Trenton. Among other amenities, there are many picnic areas such as this one shown sometime after 1945. (New Jersey Department of Environmental Protection, Division of Parks and Forestry.)

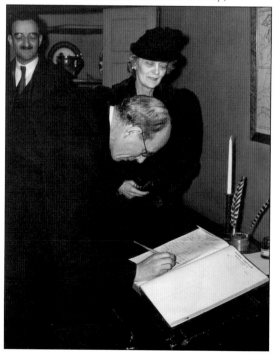

The British Lord and Lady Halifax visited the Johnson Ferry site in December 1944 as part of his trip to New Jersey as the British ambassador to the United States. The curator of the site referred to this visit as a "red letter day." The lord and lady also visited another historically important site along the Byway on this visit, the Old Barracks in Trenton. (New Jersey Department of Environmental Protection, Division of Parks and Forestry.)

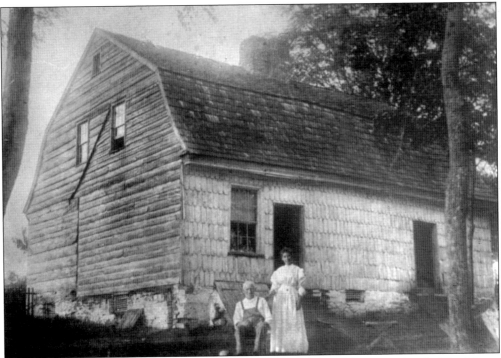

This photograph from around 1890 shows Gershom Moore and his second wife. The Moore family lived here in the Johnson Ferry House and farmed the surrounding land at the end of the 19th century. This site played an integral role during Washington's crossing of the Delaware in 1776 and is now open to public for tours as part of Washington Crossing State Park. (New Jersey Department of Environmental Protection, Division of Parks and Forestry.)

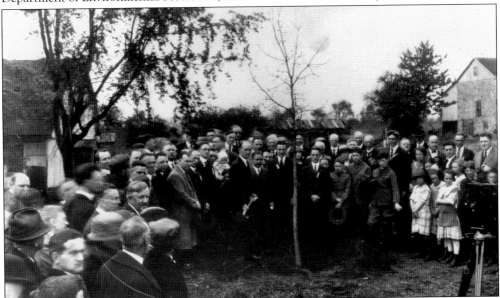

Men are hard at work in this 1930s tree-planting event at Washington Crossing State Park near the Johnson Ferry House with its historic stone barn in the background. (New Jersey Department of Environmental Protection, Division of Parks and Forestry, Washington Crossing.)

This is the Johnson Ferry House in Washington Crossing State Park. General Washington and his staff used this farmhouse and tavern to plan their attack after the night crossing of the Delaware on December 25, 1776. A wooden frame house with clapboard siding, the house features a gambrel roof. This 18th-century farmhouse was originally owned by Garrett Johnson, who also provided ferry service across the river in addition to running the tavern. Today, this historic site offers tours and interpretive programs throughout the year. (New Jersey Department of Environmental Protection, Division of Parks and Forestry.)

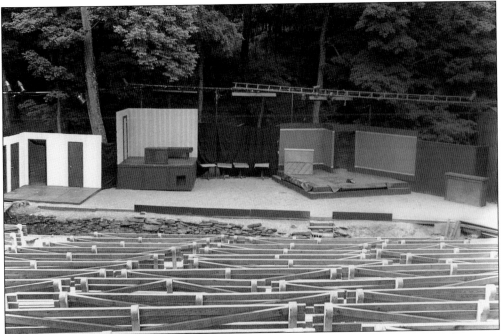

The Washington Crossing State Park Open Air Theatre was built to provide a performance venue for local theater and music. Public concerts have regularly drawn large crowds throughout the decades due in part to the unique structure of the amphitheater, which provides perfect acoustics. The Open Air Theatre continues to delight the public with performances throughout the warmer months. (New Jersey Department of Environmental Protection, Division of Parks and Forestry.)

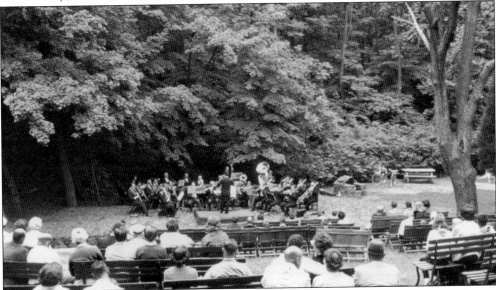

Symphonies also utilized the unique outdoor acoustics at that Washington Crossing amphitheater. The Open Air Theatre remains popular today with a full seasonal schedule of plays and musical performances. (New Jersey Department of Environmental Protection, Division of Parks and Forestry, Washington Crossing.)

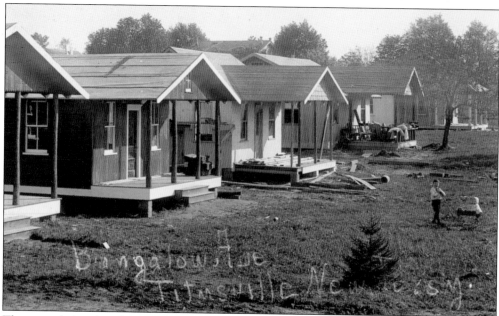

The young lad in this photograph is giving his baby sister a ride in a child's wagon that places this view of Bungalow Avenue in Titusville in the early 1920s. Titusville was a summer community during the late 19th and early 20th centuries. Families, history buffs, and nature lovers have been drawn to the areas along the Byway for generations. (Richard Burton.)

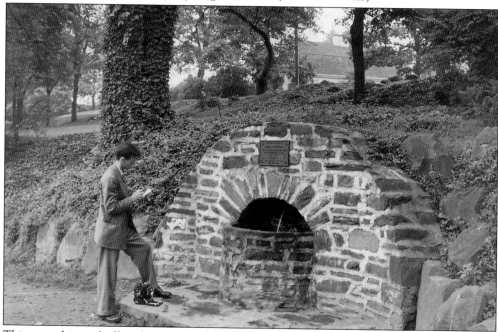

This young history buff is taking note of the garden fountain along the banks of the Delaware River erected in the early 1930s to honor John Honeyman by the Patriotic Order of Sons of America. Some historians believe that Honeyman played an integral role in the Revolutionary War as a private spy for General Washington. (New Jersey Department of Environmental Protection, Division of Park and Forestry, Washington Crossing.)

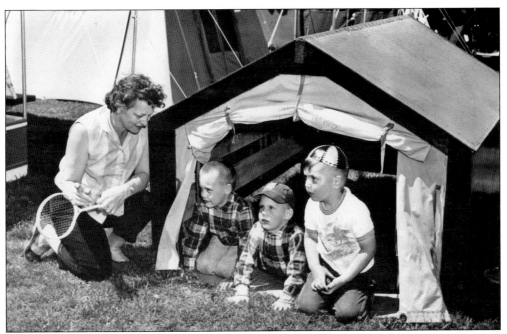

Recreational camping is common along the Delaware River Scenic Byway. This family is enjoying time at the Phillips Farm area of Washington Crossing State Park in 1962. Today, the park offers group camping for the public. (Both, New Jersey Department of Environmental Protection, Division of Parks and Forestry.)

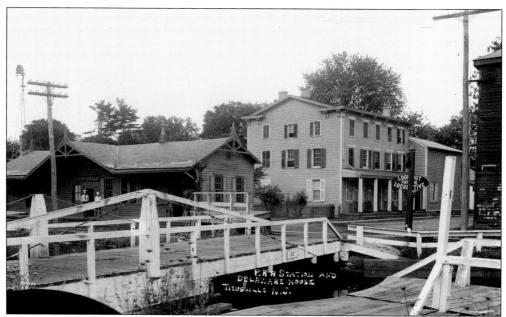

Easy access to transportation contributed to the development and success of industry along the Byway. The swing bridge over the canal in Titusville sits close by the Belvidere Delaware Railroad Depot and the Delaware House on Church Street. Chartered March 2, 1836, the Bel Del was part of the Pennsylvania Railroad and quickly supplanted the canal as a mode of transportation. (Richard Burton.)

Joseph Wilson of Stockton, New Jersey, took the commonly known fact that newborn chicks don't eat for the first 40 hours after hatching and used it to launch the live chick shipping industry. Between Wilson and Kerr Hatcheries in Frenchtown, millions of live chicks were shipped via railroad across the nation. The chicks' chirping was a familiar sound at the Stockton and Frenchtown train stations. (David Miller.)

The original entrance to Washington Crossing State Park is pictured here. Route 29 (the scenic Byway) is on the left, and Route 546 is on the right. The original stonework for the entrance is still visible along Route 29. (New Jersey Department of Environmental Protection, Division of Parks and Forestry.)

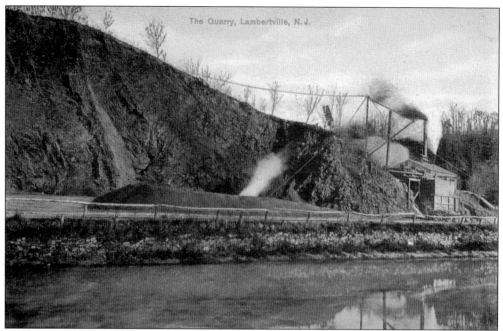

This 1910 postcard shows a quarry south of Lambertville. Many quarries were located along Route 29, supplying either brownstones or diabase. (Jeff McVey.)

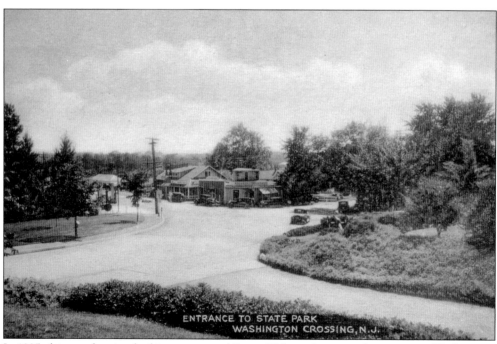

In 1935, this was the view looking out toward Route 29 from the original entrance to Washington Crossing State Park. (Delaware and Raritan Canal Commission.)

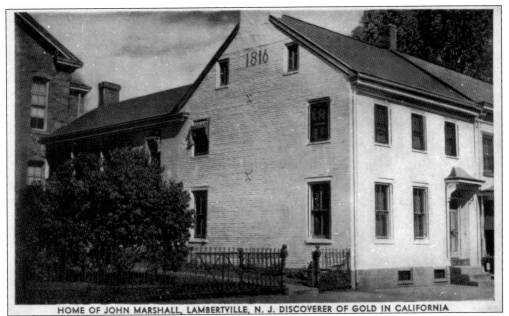

HOME OF JOHN MARSHALL, LAMBERTVILLE, N. J. DISCOVERER OF GOLD IN CALIFORNIA

This postcard shows the Marshall House on Bridge Street in Lambertville. The house was the childhood home of James Marshall, who later in life was credited with starting the California Gold Rush after he discovered gold along the American River in California. (NJDOT.)

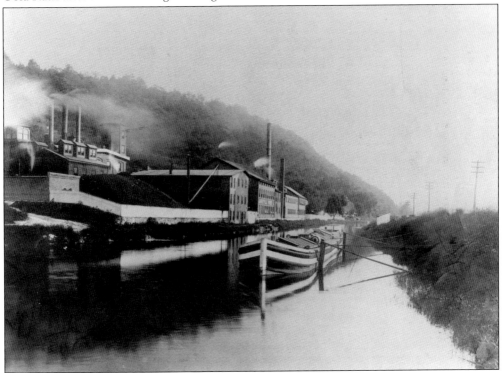

The Lambertville Rubber Works was located along what is now Route 29. This image was captured from the banks along the D&R Canal with canal boats tethered to the sides. (Delaware and Raritan Canal Commission.)

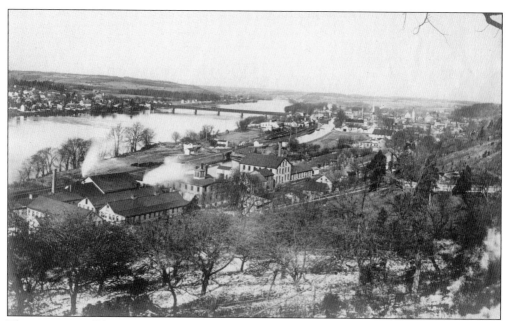

This view can still be seen today from the recently preserved lands of Goat Hill Overlook outside of Lambertville. (Delaware and Raritan Canal Commission.)

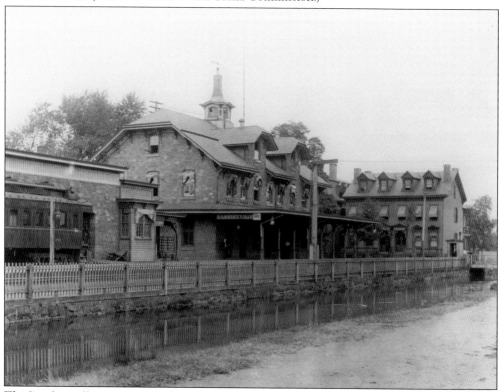

The Lambertville station of the Bel Del Line is caught in this image taken from the towpath of the D&R Canal. Today a restaurant and hotel, it retains its historic name. (Delaware and Raritan Canal Commission.)

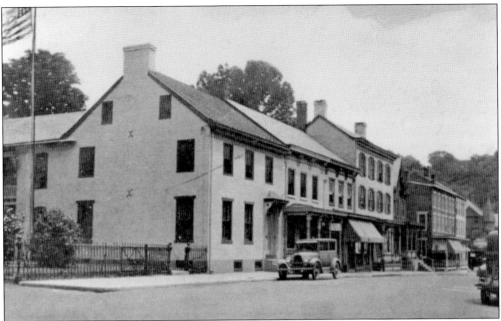

The James Marshall House
is listed in the national and
state registers. The house
is well maintained by the
Lambertville Historical
Society and often offers tours
for the public. (Lambertville
Historical Society.)

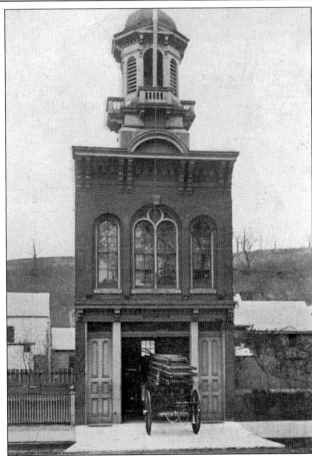

In this 1910 postcard of
the Fleetwing Firehouse in
Lambertville, a hose and ladder
truck stands in the doorway.
(Jeff McVey.)

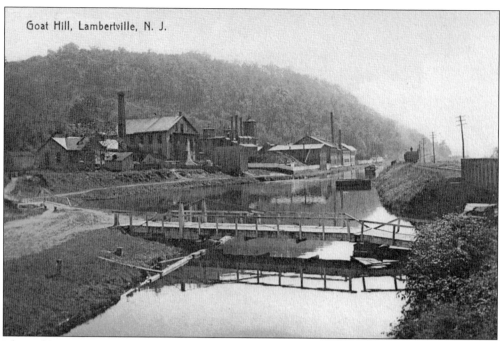

The Rubber Works was located along the canal banks south of the lock in Lambertville. In the foreground is the canal bridge, and Goat Hill can be seen in the distance. (Jeff McVey.)

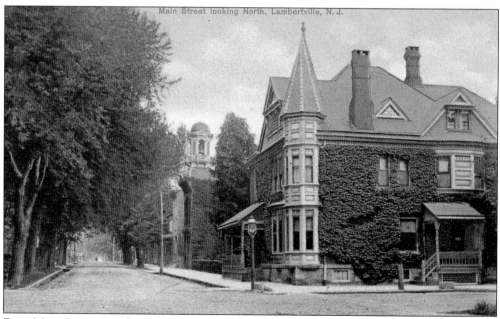

From Main Street, a pedestrian may look north at Bridge Street in Lambertville. This postcard captures the interesting rooflines of a few of the Victorian buildings in this charming riverfront town. (Jeff McVey.)

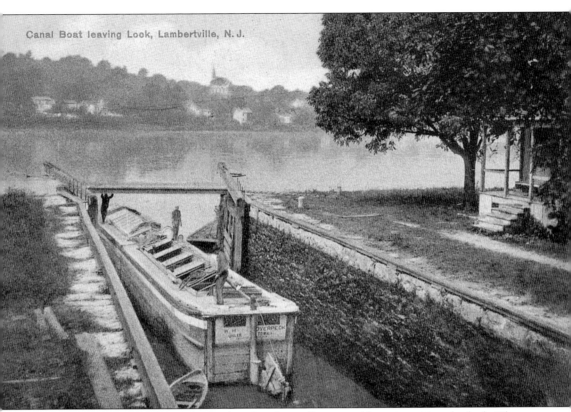

Canal Boat leaving Lock, Lambertville, N. J.

In this 1910 postcard of the Outlet Lock at Lambertville, a canal boat is exiting the lock. The toll collector's office is to the right. The city across the river, where it is heading, is New Hope, Pennsylvania. (Jeff McVey.)

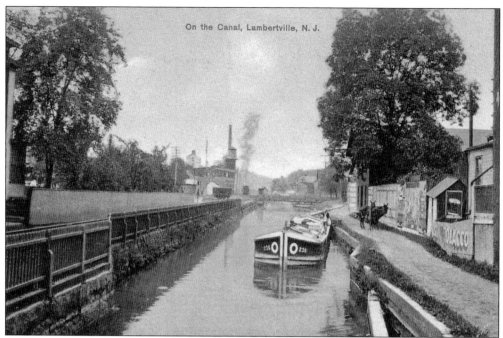

Lambertville was industrialized in 1910, but mules still pulled canal boats through the heart of town. Note the locomotive on the Bel Del puffing smoke in the distance. (Jeff McVey.)

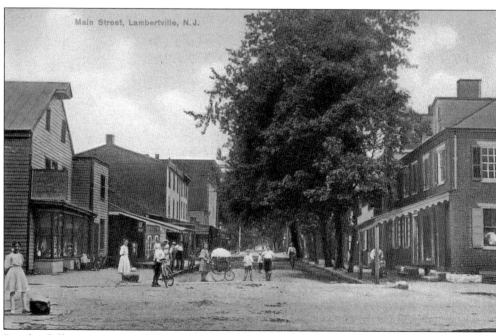

People of all ages are out and about on the dirt roads in Lambertville. This photograph was taken from Main Street looking north on Coryell Street. (Jeff McVey.)

The Lambertville Rubber Works can be seen in this postcard. Once a thriving concern producing rubber gloves for all sorts of uses, from industrial to home use, the Rubber Works met the same fate as many other industrial sites along the river. It burned to the ground in 1868. (Carl Cathers.)

All of the buildings in this early view of Bridge Street in Lambertville still exist today. While the businesses housed in most of them have changed over the years, the Lambertville House and St. John's Church have maintained their original use to this day. (Delaware and Raritan Canal Commission.)

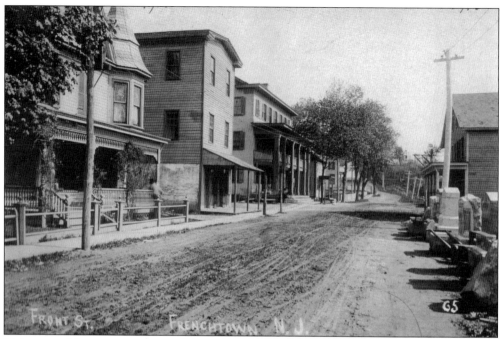

This turn-of-the-century image of Front Street in Frenchtown is another example of historic architecture still in existence in the river towns along the Byway. All of the buildings along the left side of the road still exist today. The National Hotel continues to serve visitors to Frenchtown as it did when Front Street was still a dirt road, as seen here. (David Miller.)

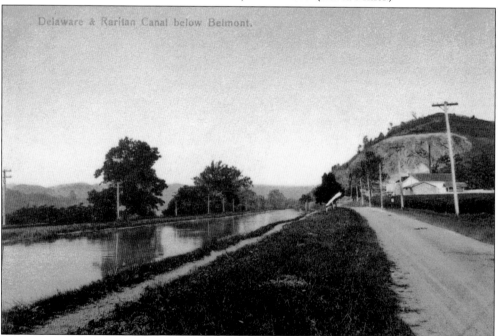

This postcard image of the D&R Canal was taken below Belmont and shows what is now the busy Route 29 (once a dirt road), the towpath, and railroad. (Delaware and Raritan Canal Commission.)

RASPUTIN'S MUSIC BERKELEY
2401 TELEGRAPH AVE
BERKELEY, CA 94704
(510) 704-1146
TRAN NO: 4110

10/29/14 18:31:14 REG: A
CASHIER: REG 1 - DAY

UC5 D124986
 QTY 1 @ $5.95 5.95T
SUGG RETL PRC: $7.44 SAVINGS: $1.49
UC5 3008260102
 QTY 1 @ $5.95 5.95T
SUGG RETL PRC: $7.44 SAVINGS: $1.49
UC5 3008260722
 QTY 1 @ $5.95 5.95T
SUGG RETL PRC: $7.44 SAVINGS: $1.49

SUB-TOTAL 17.85
SALES TAX 1.61
TOTAL DUE 19.46
ATM 19.46

YOU SAVED A TOTAL OF: $4.47

RETURNS within 8 days with RECEIPT
76% on used CDs/DVDs/LPs 6.95 and up
54% on all other items
No ins. Returns on items 1.95 or less
100% store credit on defective items
**** NO REFUNDS OF ANY KIND ****

10/20/14 18:51:14 REG: A
TRANS#: A5071 DAY

USED DISCBRAY
QTY 1 @ $9.50 $9.50
SOCE RETURNED: $7.46 SAVINGS: $1.40
DCS:308880102]
QTY 1 @ $9.95 $9.95
USED RETL PRC: $7.46 SAVINGS: $1.49
DCS:308890122
QTY 1 @ $8.98 $8.98
USED RETL PRC: $7.44 SAVINGS: $1.49

SUB-TOTAL 17.95
SALES TAX 1.61
TOTAL DUE 19.45
MDM 19.45

YOU SAVED A TOTAL OF $4.41

Returns within 8 days with RECEIPT.
See unused CDs/DVDs, LPs & 45s and up.
Same on all other items.
No price Returns on items 1.99 or less.
100% store credit on defective items.
**** NO REFUNDS OF ANY KIND ****

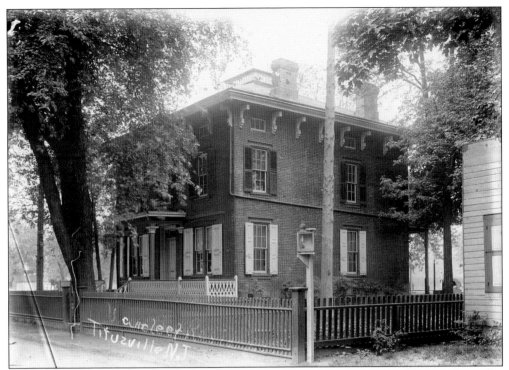

Otto Neiderer, the inventor of a mechanical device to sort eggs, lived in this home in Titusville. It remains a private home along the Delaware River today. (Karl Neiderer.)

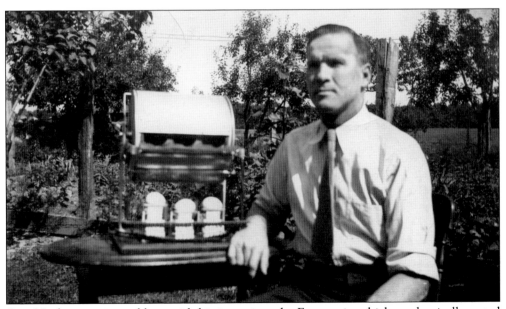

Otto Neiderer is pictured here with his invention, the Eggomatic, which mechanically sorted eggs by size, saving hours of labor. (Karl Neiderer.)

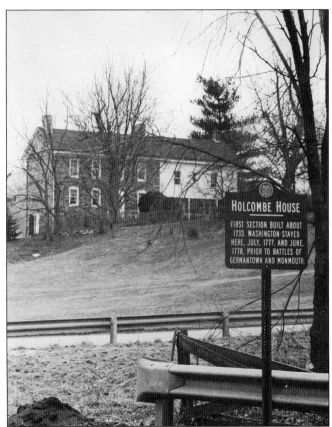

The original portion of the Holcombe House, located in the most southern part of Kingwood Township, was constructed in 1733 and may be the oldest home in the township. The house served as temporary headquarters to General Washington in July 1777 and once again in June 1778. It is seen here around 1960. (Lambertville Historical Society.)

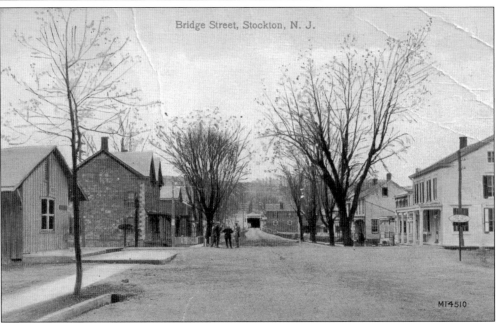

This was the view in 1910 down Bridge Street in the little village of Stockton from the road that is now the Byway. (Lambertville Historical Society.)

Byram Station and the tracks of the Bel Del appear to be nestled among the trees in 1955. The remnants of the Byram–Point Pleasant Bridge are visible through the tree line. (John Kellogg.)

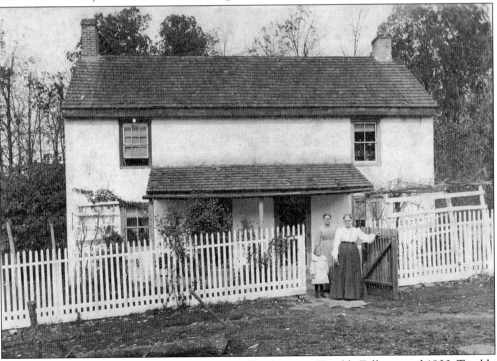

Mrs. George Chamberlain is pictured in front of her home in Tumble Falls around 1900. Tumble Falls is a little-known area along the Byway that offers much beauty through its rural nature and rocky waterfalls. Byway visitors are now able to explore Tumble Falls along a short trail located directly off Route 29 north of Byram. (Lambertville Historical Society.)

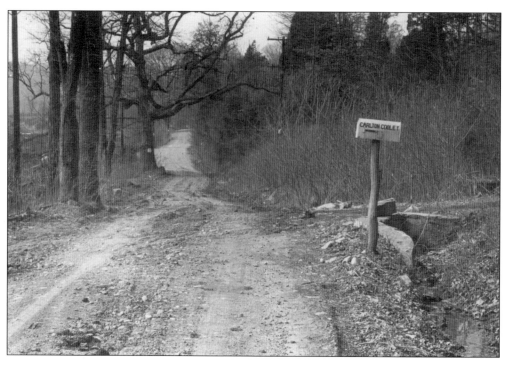

In the above image, the Cooley mailbox sits along a dirt road on March 9, 1954. By May of the same year, a new road in progress can be seen in the photograph below. Due to construction and funding issues, the new roadway would not be completed and opened as the new Route 29 until August 12, 1960. (Both, John Kellogg.)

Four

BRIDGES

The first bridge to span the river, opened to traffic in 1806, was a wooden covered structure at the site of the current "Trenton Makes" bridge. Its stone masonry still supports the replacement bridge, erected in 1928. Two additional bridges plus a railroad trestle connect New Jersey to Pennsylvania at Trenton.

Calhoun Street Bridge, the oldest roadway structure between the two states, was 130 years old in 2013. As the longest and the only wrought iron bridge in the Delaware River system, it is listed in the National Register of Historic Places and on the historic registers of both states.

The third Trenton to Morrisville Bridge, carrying US Route 1, is of modern construction (1952), as is the bridge at Scudder Falls (1958), which carries Interstate 95. It replaces the Yardley-Wilburtha Bridge, which was destroyed in the flood of 1955 and never rebuilt. A veteran's memorial plaque stands at the Yardley end on River Road, and stone piers still mark its location.

At Washington Crossing, floods carried away the first and second bridges built in 1831 and 1842. The existing superstructure, a double Warren truss, was erected in 1904 on the original stone-faced rubble piers.

Connecting New Hope to Lambertville is a bridge built in 1904 as a private toll bridge. It was the third at this location, replacing wooden bridges carried away in the floods of 1841 and 1903. It is the only steel truss bridge in the system, and supports the most pedestrian traffic. The cantilevered walkway on the downstream side affords a nearly unrestricted view as far as the next bend in the river.

A second New Hope–Lambertville Bridge bypasses the two towns entirely, carrying Route 202 over the river on a modern toll bridge.

The Centre Bridge–Stockton wooden span at Reading's Ferry (1914) was the only bridge not seriously damaged in the 1903 flood. A fire demolished it in July 1923, and a six-span riveted steel Warren truss structure replaced it in 1927.

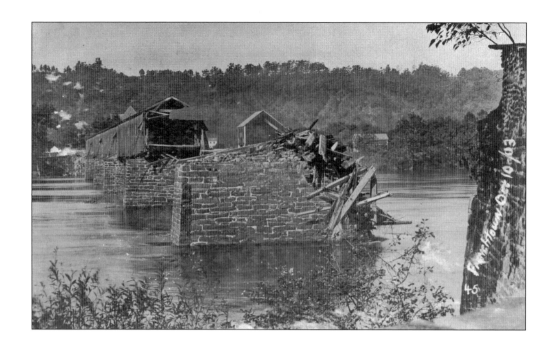

The remnants of the Frenchtown-Uhlerstown Bridge are seen here from the Frenchtown side of the river after the "Pumpkin Freshet" of 1903. A freshet is a sudden rise of rivers and streams due to heavy rains or quickly melting snow. The Delaware River crested on October 10, 1903, after three days of heavy rain. (Both, David Miller.)

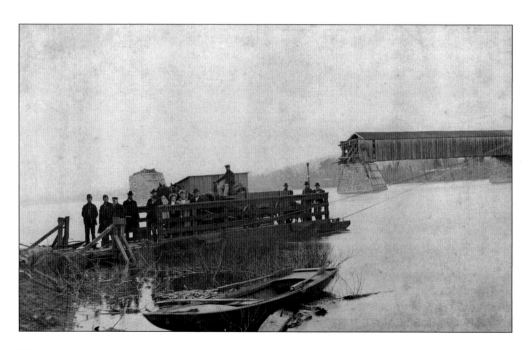

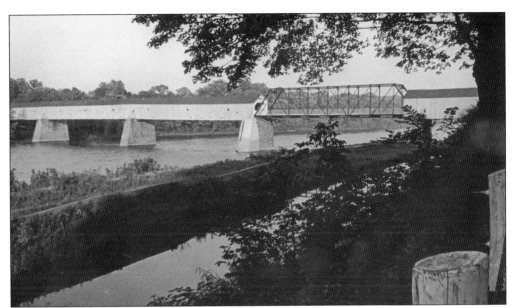

Following the 1903 flood that carried off the first two sections of the Stockton bridge, those two sections were rebuilt as a truss bridge. This image looking across the canal shows the two different parts of the bridge to Center Bridge. (Lambertville Historical Society.)

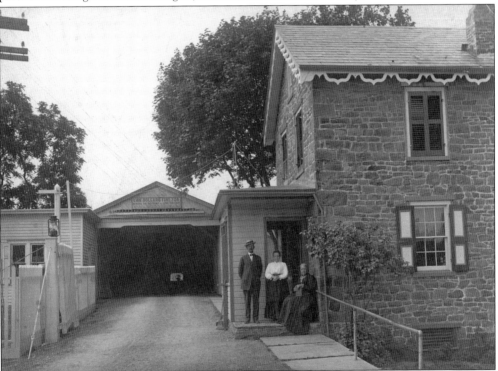

This 1920s photograph shows bridge tender Reading Dilts, his wife (seated), and Carrie Wilson at the canal bridge on the Stockton side of the Centre Bridge. The bridge tender was on duty 24 hours a day and lived in this stone house with his family. Sylvester Ledger was the last bridge keeper to live in the house, which was torn down in 1952. (Carl Cathers.)

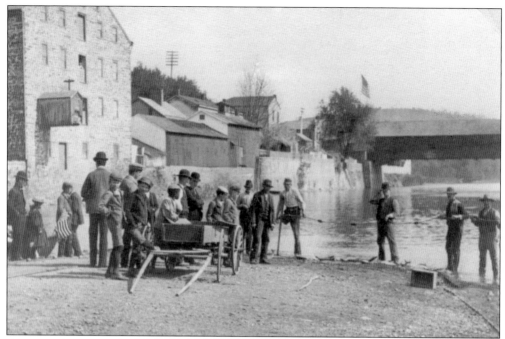

A group of men are shad fishing near the Lear Mill north of the Lambertville Bridge in this 1898 photograph. Lambertville's Lewis Fishery has been in business since 1888 and is the only remaining commercial shad fishery on the upper Delaware River today. This migratory fish has played an important role as a food source and commodity throughout the centuries along the Byway. (Delaware River Mill Society.)

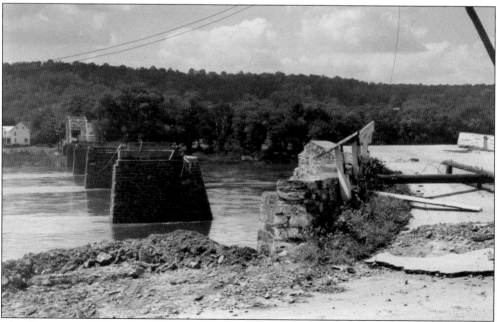

The flood of 1955 remains the worst natural disaster to hit the area along the Byway. A result of two separate hurricanes that hit the area within less than a week, it resulted in the Delaware River cresting at a record high 38.85 feet as measured by the Riegelsville gauge. (John Kellogg.)

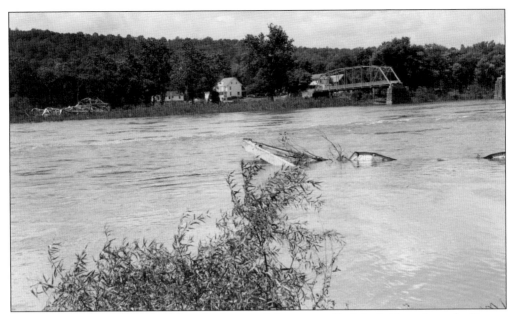

Hurricanes Connie and Diane caused substantial damage to all of the bridges along the Byway. All of the crossings sustained damages, but the Byram–Point Pleasant Bridge was the only bridge in Hunterdon County that was completely wiped out from the flood of 1955. The Bridge Commission chose not to rebuild it; the remnants of the bridge are still visible today. These shots taken on August 19, 1955, show the aftermath of the storms that devastated the east coast from New England to the Carolinas. (John Kellogg.)

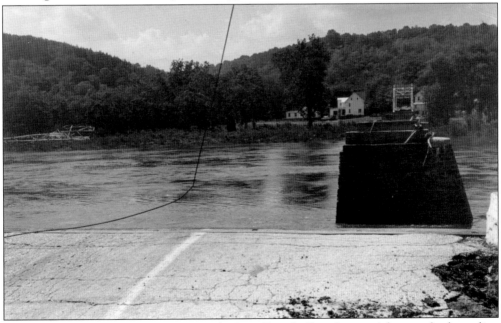

Eight states were declared disaster areas by Pres. Dwight Eisenhower. Adequate food supplies, shelter for displaced residents, and clean drinking water were a priority. Lack of drinking water led to widespread inoculations against typhoid. While there have been other floods since 1955, none have matched the Diane flood's level of destruction. (John Kellogg).

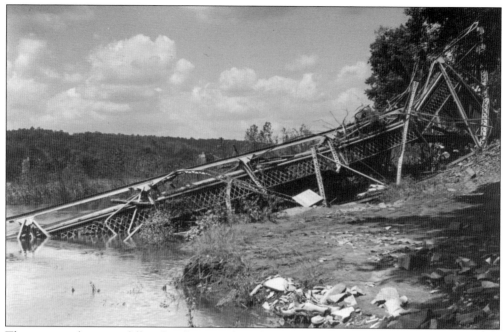

There is a resiliency to folks who choose to live along a river. For those who build their lives in a river community, it's the power and the majesty of the river that ties it all together. There is a strong sense of community forged during times like the Diane flood that is the hallmark of the river towns along the Byway. (John Kellogg.)

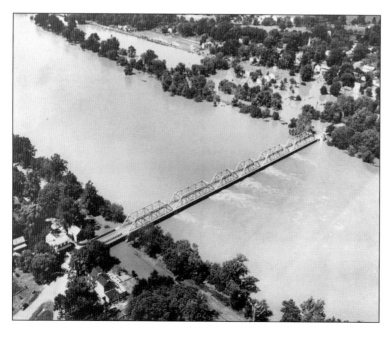

This aerial view shows the Stockton Bridge at the height of the 1955 flood. The town of Stockton was flooded up to the Stockton Inn porch. The Diane flood was responsible for close to 200 deaths along the eastern seaboard and over $1 billion in damage, making Diane the first "billion dollar hurricane" in US history. (Delaware River Mill Society.)

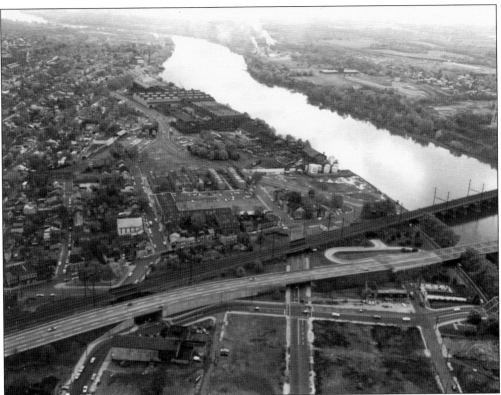

This newly constructed extension to Route 29 provides access to the bridges to Pennsylvania. Morrisville, Pennsylvania, is on the opposite bank. Smoke from the still-busy factories fills the sky. (NJDOT.)

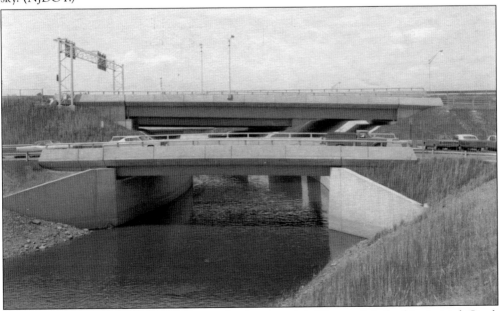

Parallel to Route 29, two small bridges cross the Assumpink in Trenton. Much of Assumpink Creek has been covered over in the city. This photograph was taken on February 27, 1968. (NJDOT.)

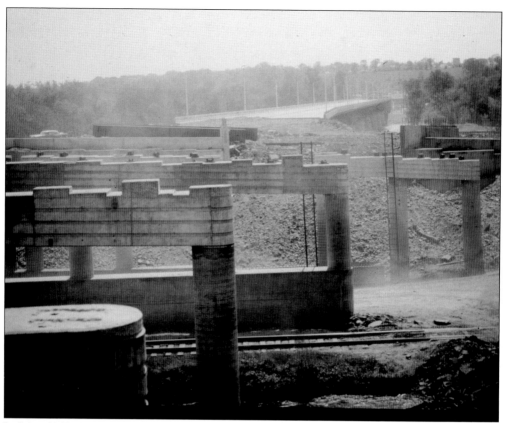

In May 1960, construction was approaching the Scudders Falls Bridge for Route 29 and Bear Tavern Road. Note the railroad tracks still in place beneath the bridge supports. (NJDOT.)

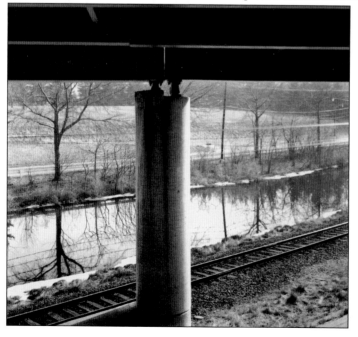

By 1968, the Scudder Falls Bridge, built in 1959, had begun to deteriorate. Plans for a new 11-lane bridge to carry I-95 across the river were initiated. This photograph from under the bridge shows the already deteriorating pillars and rusting girders of the relatively new structure. (NJDOT.)

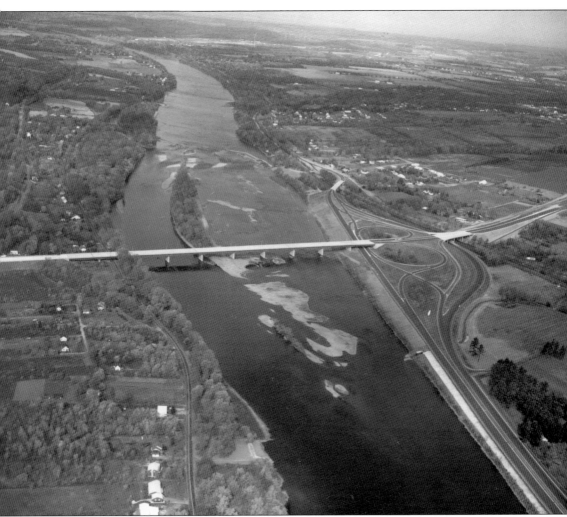

In 1961, this was the view looking north of the Scudder Falls Bridge. The bridge gave access to I-95 and I-295, dramatically increasing commerce, transportation, and access to New York City along the I-95 corridor. The immediate landscape is much more built up compared to just five years earlier. Note that while the Byway intersects with this major transportation artery, it returns to its river road beauty within a mile. (NJDOT.)

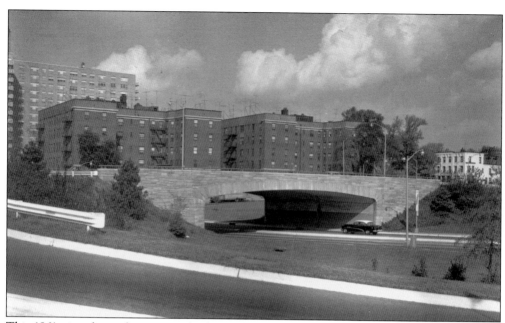

This 1961 view shows the overpass bridge at the Calhoun Street cloverleaf leading to the State Street capitol complex buildings, state museum, and planetarium. The view of the overpass is exiting Route 29 traveling south on the Byway. (NJDOT.)

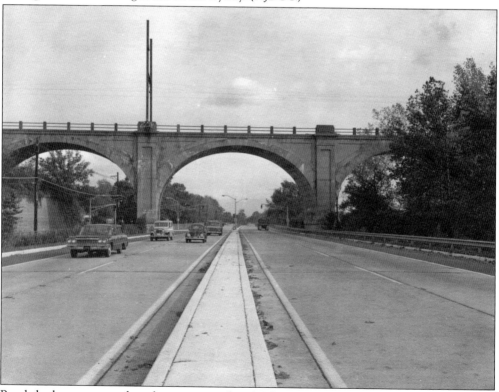

Roads had to accommodate the existing railroad. This overpass bridge over the Byway is near Lower Ferry Road. (NJDOT.)

Assunpink Creek and the Stockton Street Bridge are seen here in 1953. Assunpink Creek was the site of the second Battle of Trenton, where Washington's troops delivered a second blow to the British, who came from the north and positioned themselves near the bridge. After holding Trenton, they were able to move on to the decisive Battle of Princeton. (NJDOT.)

This early image of a bridge on River Road reflects the rural nature of the roadway before the "dualization" of Route 29. (NJDOT.)

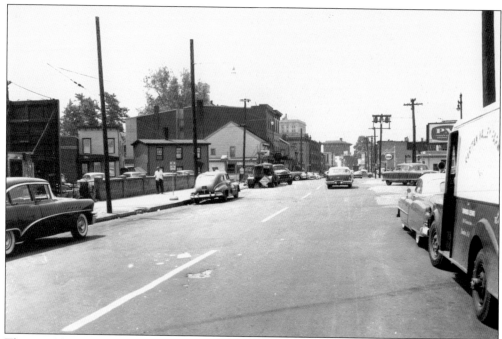

The canal bridge at Jet Spring and Willow Street is pictured here in 1956. (NJDOT.)

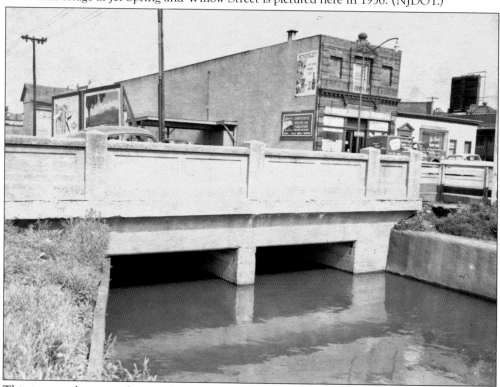

This is a much more substantial and commercial canal bridge at Warren Street in Trenton. The sign advertises the Lawrence Drive-in Theatre. Drive-in movies were popular in the 1950s. (NJDOT.)

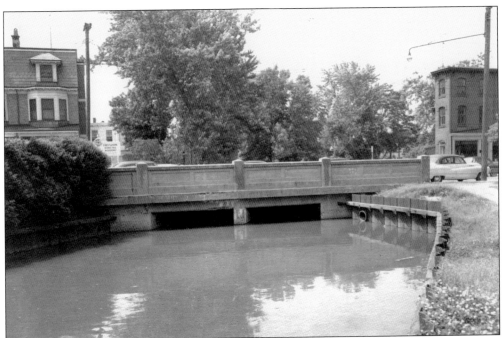

Another feeder canal bridge is shown here on West Hanover Street in 1956. The Thomas Edison State College academic building is on West Hanover. It offers degrees to nonresident students, often military personnel, who need never attend a class on campus and can study where they are. (NJDOT.)

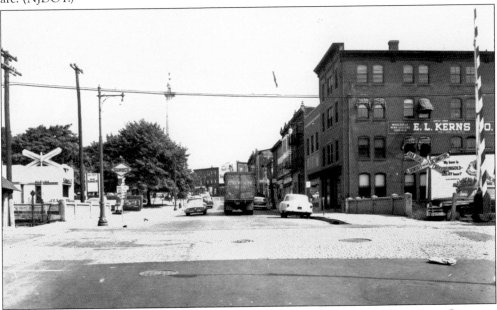

This canal feeder bridge over North Broad Street is pictured in 1956. The E.L. Kerns Company was a bottling company begun by Kerns and his wife, Mary, in 1889. They were successful enough to erect this four-story building at 302 North Broad Street for a factory in 1896. They bottled soda, beer, wine, and liquors. Kerns glass bottles are collectibles with prices ranging from $15 to $40. (NJDOT.)

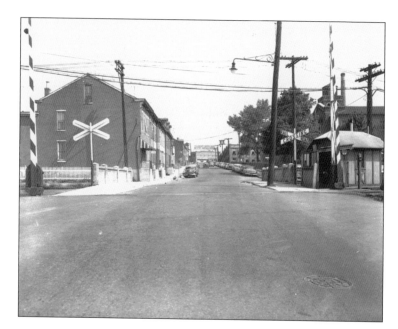

This obviously citified bridge spans the feeder canal on Montgomery Street in Trenton. (NJDOT.)

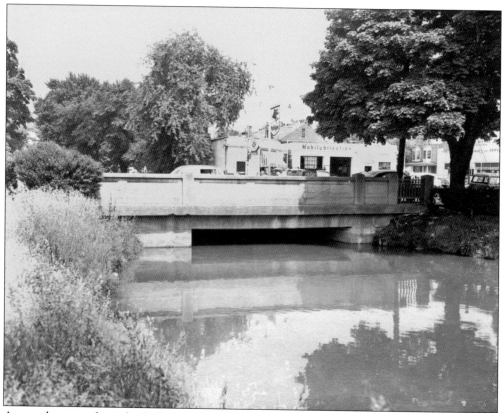

Across the street from the feeder canal bridge at Calhoun Street in 1956, a Mobil station offers "Mobilubrication." (NJDOT.)

This 1956 photograph shows a canal bridge at Scudder Falls. Recently, a new bridge was constructed replacing the one shown. (NJDOT.)

This bridgetender's house is located near the feeder canal on Wilburtha Road. Wilburtha, a community of mainly single-family homes in Ewing Township just north of Trenton, was once connected to Pennsylvania by a bridge to Yardley. Destroyed by Hurricane Diane in 1955, the bridge was never rebuilt. (NJDOT.)

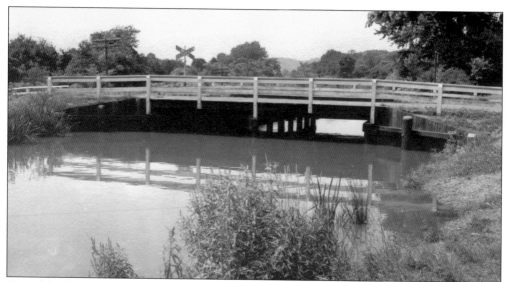

One of the larger feeder canal bridges at Titusville, an unincorporated area of Hopewell Township, is located just at the north end of Washington Crossing Park. The community of Titusville is bisected by Route 29. Three bridges connect the residential river portion of the town to the Byway. (NJDOT.)

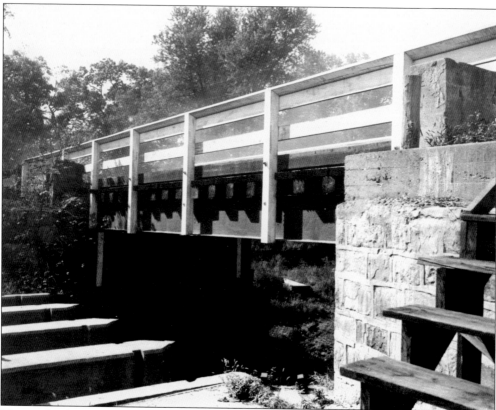

This is the first bridge south of the quarry above Lambertville across the feeder canal. The photograph dates from 1953. (NJDOT.)

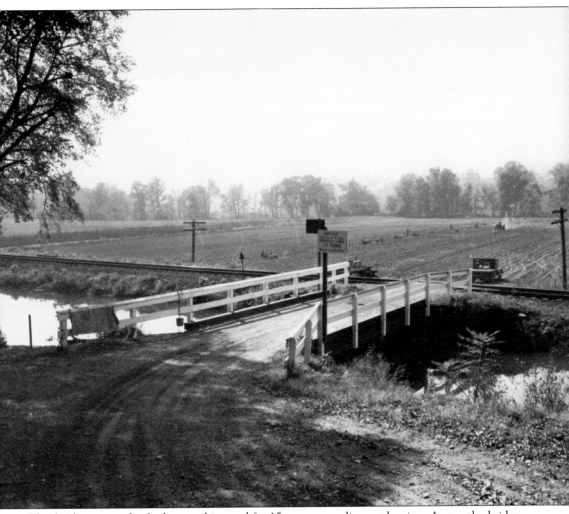

This bridge across the feeder canal is rated for 15 tons, according to the sign. Across the bridge, workers are harvesting crops—perhaps melons, judging by the shapes in the back of the truck. In the distance, a tractor kicks up dust as it moves along the field. These fields were once farmed by inmates from the Mercer County Workhouse. (NJDOT.)

After the D&R Canal ceased operation in 1932, the many bridges crossing it were left unchanged. Along the upper, more rural part of the canal, all the bridges were similar in size and design. (NJDOT.)

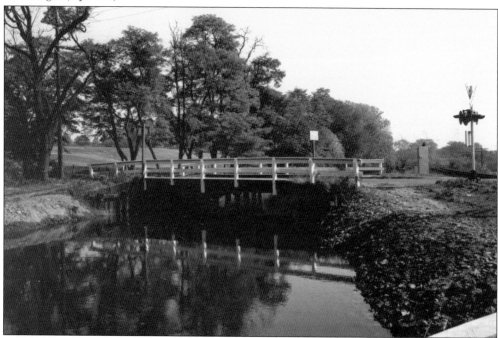

Many small roads crossed the feeder canal in the reaches above Trenton. This photograph was taken close to the intersection of Route 29 and Pleasant Valley Road. The signal is for the Bel Del train. (NJDOT.)

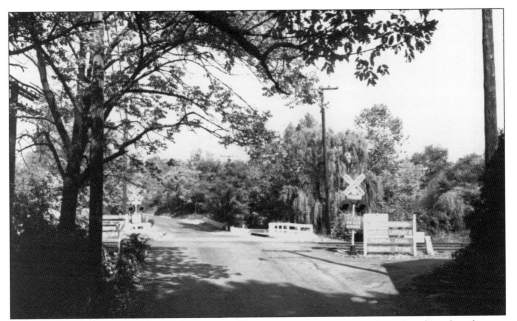

A small railroad bridge over the feeder canal boasts an advertisement for a local coal and stone supply store. (NJDOT.)

This November 1953 photograph was taken in the early morning. The sign reads "No Parking on This Side." (NJDOT.)

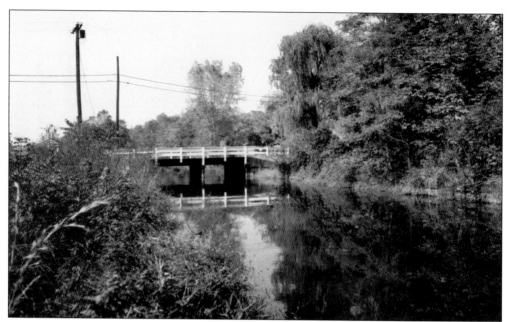

Seen here is a hidden bridge over the canal. This area is now a very secluded section of the Delaware Canal Trail. (NJDOT.)

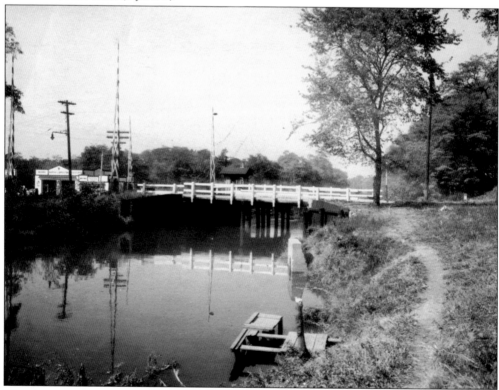

Clearly a more important and busier crossing of the canal, this bridge has both a railroad crossing barrier and a house for the crossing tender. The small dock in the foreground is in bad repair, although the rudimentary tie-up post appears functional. (NJDOT.)

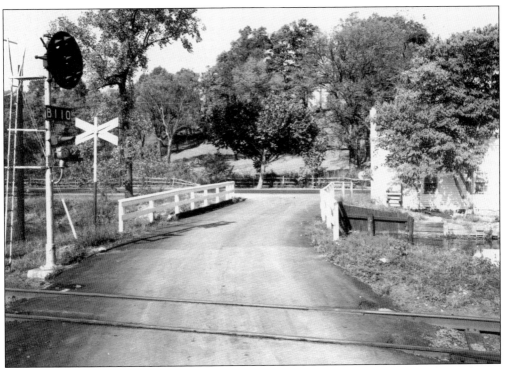

Pictured here is a grade level railroad crossing with its warning signs and lights. (NJDOT.)

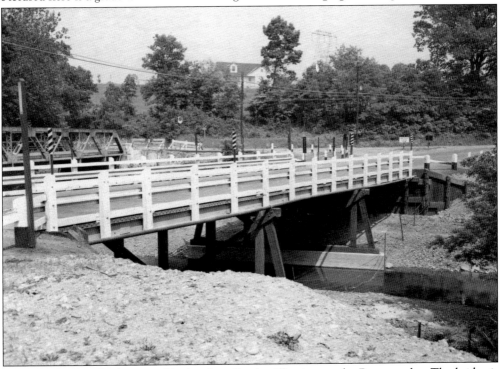

The Alexhawken Bridge over Alexhawken Creek still exists on the Byway today. The bridge is just north of Lambertville, just before the present Route 202 Byway Toll Bridge. (NJDOT.)

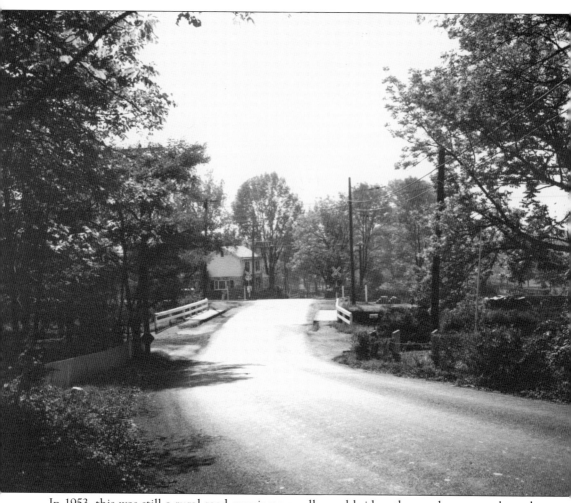

In 1953, this was still a rural road crossing a small canal bridge, the northernmost along the feeder canal. (NJDOT.)

Five

THE BYWAY TODAY

A National Byway must satisfy at least one of six criteria: scenic, natural, historic, cultural, architectural, or recreational. History, outdoor recreation, and scenery are the most significant intrinsic qualities of this Byway, though it really embodies all six. Designated October 16, 2009, the Byway today has something of interest for every visitor.

A leisurely hour's drive from Trenton to Frenchtown offers landscaped parks, bucolic farms, dramatic cliffs, tumble falls that become dramatic ice sculptures in winter, forests, and of course, the canal and the river viewed through gaps in the trees.

The naturalist can marvel that a National Wild and Scenic River flows in this populated area, a Special Protection Water of the state. Ten natural heritage sites protect rare and endangered plant and animal species. Located along the Atlantic Flyway, the corridor is also a hot spot for birders.

The history buff will revel in the Washington's Crossing story, and in the mills, farms, and buildings of colonial and Victorian times. Thousands of tools and ceramics from a Lenape settlement of 2,800 years ago have been preserved from an archeological dig. Howell Living Farm, an extant 18th-century farm, offers programs throughout the year. The Prallsville Mill complex at Stockton offers tours and trail access.

Hundreds of art galleries, antique shops, museums, live theater, and musical events, along with numerous art exhibits displaying well-known regional artists tempt the cultural visitor. Bookshops feature local authors. Nineteenth-century inns offer fine dining. Each river town mounts seasonal festivals. All year, nearly every weekend offers a different event, including a festival celebrating the annual spawning run of the shad. *Forbes* magazine voted Lambertville one of America's prettiest towns in 2013.

For cyclists, the Byway offers many miles of paved shoulders. Tubers, kayakers, boaters, and fishermen enjoy easy access to the river. Hikers, bikers, and those merely out to walk their dogs utilize the 35-mile multiuse recreational trail that once served as the Bel Del rail line and the D&R Canal towpath.

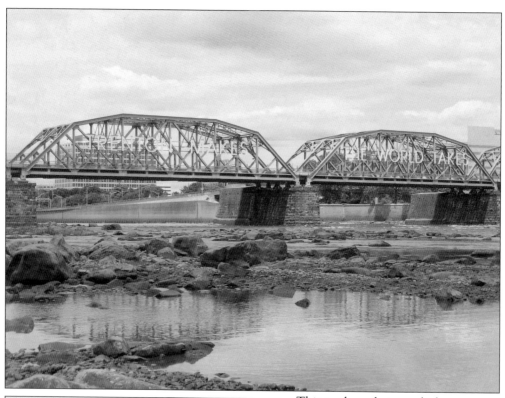

This modern photograph shows the bridge connecting Trenton to downtown Morrisville, Pennsylvania. The red neon sign has brightened the night over the Delaware River since the 1930s. This famous landmark's soft glow welcomes visitors to the Byway approaching in the night. (National Park Service.)

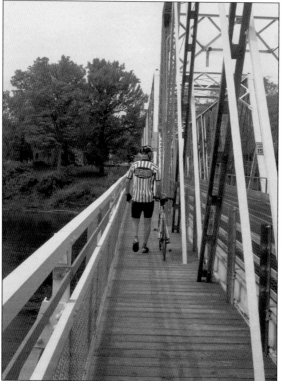

The Washington Crossing Bride connects New Jersey and Pennsylvania's Washington Crossing State Park. The historic village of Taylorsville flanks the Pennsylvania side and Titusville on the New Jersey side. The narrow bridge also offers a pedestrian walkway. Although the Byway is bike friendly, all bicyclists traveling on the Byway must walk their bikes across the bridge. (National Park Service.)

Fishing is easy on the Delaware River Scenic Byway, and many river access points are well marked and offer easy boat launches. This photograph shows a fisherman just off Bulls Island. Shad is the big catch every spring. One of New Jersey's largest street festivals, Lambertville hosts Shad Fest every April. (National Park Service.)

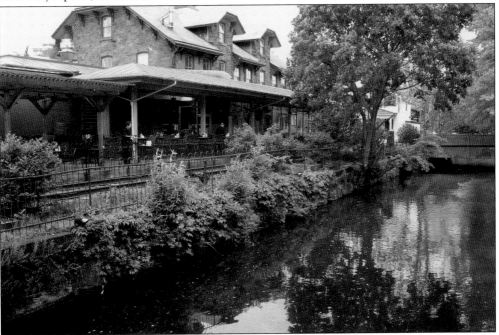

This is the current Lambertville Station Restaurant and Inn on the D&R Canal. Located in the center of Lambertville, just off the Lambertville–New Hope free bridge, it is the former Bel Del railroad station and is easily accessible by foot, bike, or car. (National Park Service.)

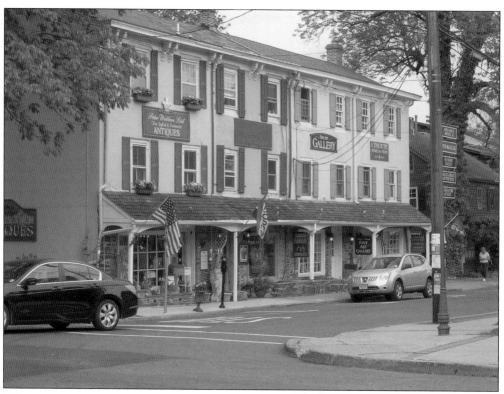

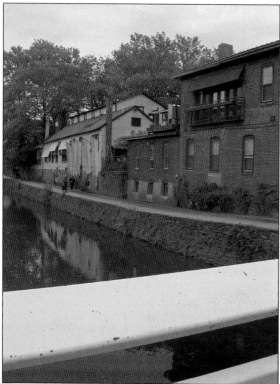

The historic district of Lambertville offers the charm of historic buildings, river views, and a wide selection of art galleries, antique shops, and gift shops. This quaint row of shops is located next to the free bridge and runs parallel to the river. Lambertville is a walking-friendly city. (National Park Service.)

This is a view from one of the many still-used canal bridges along the Byway showing the canal towpath in downtown Lambertville. The path, open along the complete Byway, is bike and pedestrian friendly, offering views of the canal, shops, restaurants, and gardens. (National Park Service.)

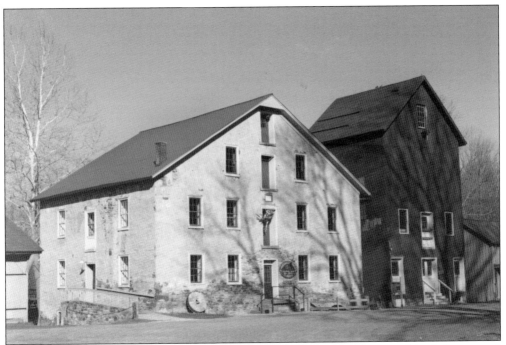

Location has allowed the Prallsville Mills to grow and prosper. Now, as a part of the Delaware and Raritan Canal State Park and the center point of the Delaware River New Jersey Scenic Byway, the mill is poised to continue that growth and success. (Delaware River Mill Society.)

A variety of programs and events as well as plenty of open space in which to wander make the Prallsville Mills complex a center for history, the arts, ecotourism, and a variety of community and recreational activities. (Delaware River Mill Society.)

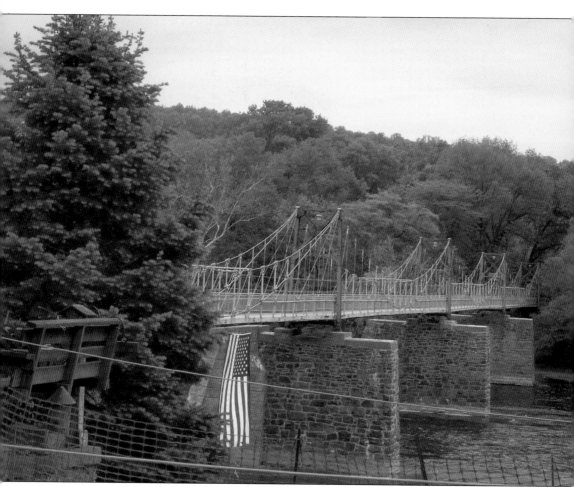

This view looking south toward the Lumberville–Raven Rock Bridge, also known as the Bulls Island Pedestrian Bridge, is only for walking; even bicyclists must walk their bikes. The bridge is one of many jewels on the Byway today and connects the historic Pennsylvania village of Lumberville and the New Jersey state recreational area on Bulls Island. The bridge is easily accessible by bike or walking. (National Park Service.)

A pedestrian's view of the Lumberville–Raven Rock Bridge reveals this Roebling bridge's structure. This is a unique suspension bridge, which offers spectacular views of the river and opportunities to see the returning population of nesting bald eagles. Roebling bridge enthusiasts have this on their must-see list. (National Park Service.)

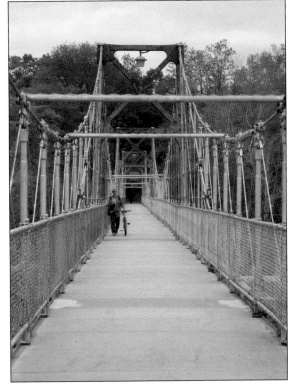

This Pennsylvania view looking at the Lumberville–Raven Rock bridge, also know as the Bull's Island pedestrian bridge, reveals the tree-lined park and towpath in the New Jersey state park. The Bulls Island park offers birding, camping, and other programs. (National Park Service.)

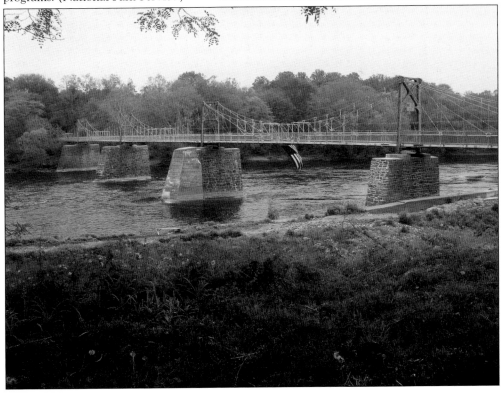

Tumble Falls, located in the upper section of Hunterdon County, is within the park but is a short hike off the Byway. The views are spectacular. The hike requires good walking shoes for those who are up for a physical challenge. Those intending to make this hike should take a walking stick or pick one up in the shops along the Byway. (National Park Service.)

The beautiful Frenchtown-Uhlerstown Bridge connects Frenchtown, New Jersey, and Uhlerstown, Pennsylvania. Frenchtown is the most northern town on the Byway and offers cafes, shops, galleries, lodging, and river access. The bridge offers a pedestrian walkway and spectacular views of the river. The entire Byway is accessible by bicycle from Frenchtown to Trenton. (National Park Service.)

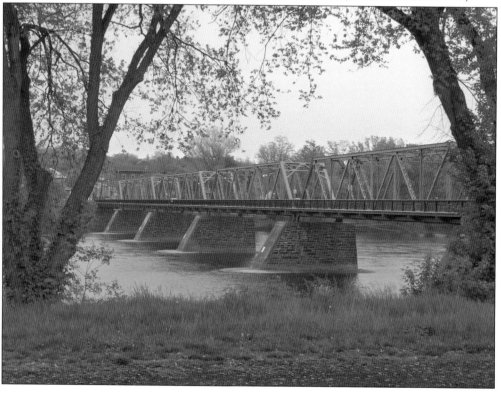

The DRSB is the first Byway in New Jersey to be "signed." Visitors should look for these signs when approaching and entering the Byway, while traveling the Byway, or at turns in the road. Byway signs serve as important directional markers and for creating a regional identity and sense of place. These are samples of Byway signs in Trenton and in the rural sections of the Byway when traveling north. Travelers on the Byway should look for the free annual DRSB Byway guide to help find visitor resources, historic site contacts, and visitor information. The guide is also available online. (Above, Cindy Bloom-Cronin; below, E.S. Sharp.)

DISCOVER THOUSANDS OF LOCAL HISTORY BOOKS FEATURING MILLIONS OF VINTAGE IMAGES

Arcadia Publishing, the leading local history publisher in the United States, is committed to making history accessible and meaningful through publishing books that celebrate and preserve the heritage of America's people and places.

Find more books like this at
www.arcadiapublishing.com

Search for your hometown history, your old stomping grounds, and even your favorite sports team.

Consistent with our mission to preserve history on a local level, this book was printed in South Carolina on American-made paper and manufactured entirely in the United States. Products carrying the accredited Forest Stewardship Council (FSC) label are printed on 100 percent FSC-certified paper.

MADE IN THE